P9-DEE-457

RECIPES FOR GOOD LUCK

RECIPES FOR GOOD LUCK

THE SUPERSTITIONS, RITUALS, AND PRACTICES OF EXTRAORDINARY PEOPLE

BY

ELLEN WEINSTEIN

CHRONICLE BOOKS

SAN FRANCISCO

Library of Congress Cataloging-in-Publication Data available.

ISBN: 978-1-4521-6218-8

Manufactured in China

Design by Kristen Hewitt

10 9 8 7 6 5 4 3 2 1

Chronicle Books LLC
680 Second Street
San Francisco, CA 94107
www.chroniclebooks.com

CONTENTS

INTRODUCTION

"IN THE PARTICULAR IS CONTAINED
THE UNIVERSAL." —JAMES JOYCE

A few years ago, while illustrating an article about superstitions, some of the behavior described in the piece sounded eerily familiar. In that moment of recognition, I became aware of my own quirky behavior and started to notice some similar patterns among my friends and colleagues. Prior to a canoe-paddling race, one of my teammates knelt down on the beach, grabbed a fistful of sand, and released it while adjusting her visor. I thought nothing of this until the same ritual was performed at the next race and the ones that followed. At another friend's book release party, he shared a specific routine he followed on the day his books are published.

Although not a big baseball fan, I love to watch batters step up to the plate and go through their own good luck rituals before taking a swing: specific ways of adjusting a helmet, moving their feet, or touching a necklace. When I heard an interview with the musician Thom Yorke in which he shared his preperformance ritual, I wondered how many other accomplished and acclaimed leaders in their fields also had similar superstitions, rituals, or practices that were integral to their process and work. My curiosity led me

behind the doors of dressing rooms, inside artists' and writers' studios, through locker rooms and laboratories, and even, on occasion, inside bedrooms.

And what I discovered is that these behaviors were a common thread across all professions, borders, and eras. In interviews with writers, the question "do you have any writing superstitions?" appears often, as it does with athletes. And while I became used to hearing about the superstitious beliefs of creatives and performers, the discovery that even Nobel Prize–winning scientists could harbor superstitions was a revelation. Some people, I found, have specific rituals to get into a frame of mind for competition. A good number of the athletes and creatives in this collection credit their adherence to their ritual as a key ingredient to their success. For others, their routine offers a way to focus. Sometimes, it stems from a desire to control the uncontrollable and ward off bad luck by making good luck. Others have work and routines that are so intertwined that one cannot begin to separate one from the other. Within these pages are a chef who uses music as a key ingredient in the kitchen, a renowned author who begins writing her novels on the same exact date, and a famed general who had a fear of black cats. With every new discovery made in my research, iconic figures started to feel more relatable. They have their own quirks and idiosyncrasies, and look at what they have accomplished! I started to see my superstitions and routines less as something odd and more as part of my own process and path.

The Nobel Prize–winning physicist Niels Bohr, another subject contained here, was asked why he kept a horseshoe above his

laboratory door. Did he believe it was good luck? He replied that he didn't believe in it, but he had been told that it worked whether one believed in it or not. Who among us couldn't use a little luck?

I share these superstitions, rituals, and practices of athletes, writers, artists, architects, scientists, musicians, political figures, and actors with the goal of celebrating that which makes us unique. I hope you will enjoy this peek behind the curtain at the process of these iconic figures at work and perhaps recognize some of yourself in their behaviors and superstitions. I hope their stories encourage you to embrace the beliefs, rituals, and routines that help you face the world with ambition and confidence and inspire you to go on making good luck of your own.

AGATHA CHRISTIE

BATH TIME APPLES

Famed mystery author Agatha Christie (1890–1976), who
wrote such classics as *Murder on the Orient Express*, munched
on apples in the bathtub while envisioning murder mysteries.
Her bath time routine appears to have brought her success:
she penned more than sixty detective novels over her career
as well as the long-running play *The Mousetrap*, and her novels
have sold an estimated two billion copies.

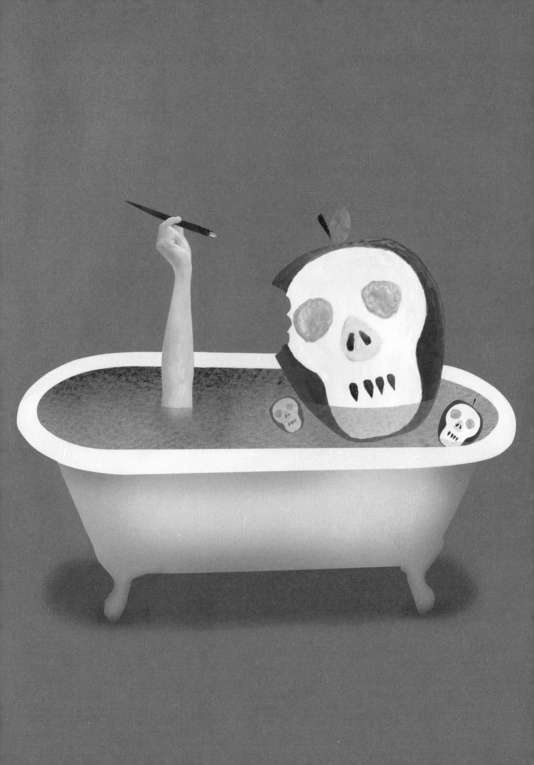

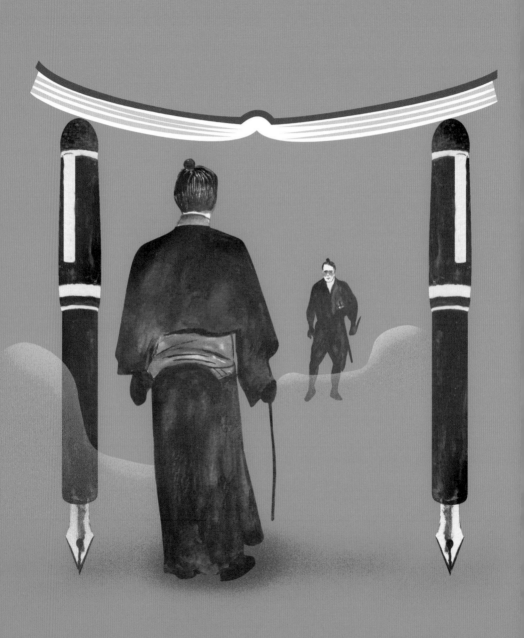

AKIRA KUROSAWA

KEPT A NOTEBOOK AT HIS SIDE

Acclaimed film director Akira Kurosawa (1910–1998) achieved international fame for such classics as *Rashomon*, *Seven Samurai*, and *Ran*. To produce his unique style of visual storytelling, he relied on words as much as images. Writing was an integral part of his practice throughout his career, and he kept a notebook as his constant companion. In his notebooks, he would record his observations and reactions to books he was reading and said that reading his notebooks would provide him with a breakthrough when he was stuck writing a script.

ALFRED HITCHCOCK

CAMEO APPEARANCE

Alfred Hitchcock (1899–1980), famed film director of such classics as *Psycho* and *The Birds*, had a custom of making a cameo appearance in his films. What began due to a shortage of extras developed into a superstition that a film would flop at the box office if he did not make an appearance. Hitchcock's hugely influential and critically acclaimed career spanned six decades, during which he directed more than fifty feature films that earned him the nickname Master of Suspense.

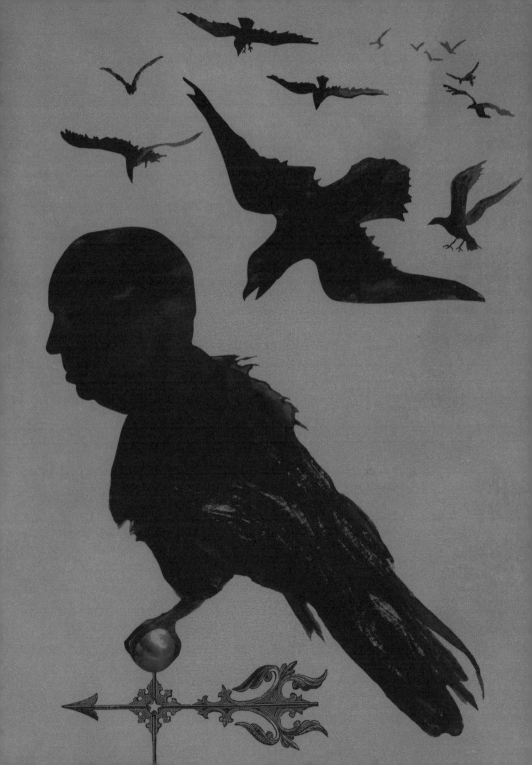

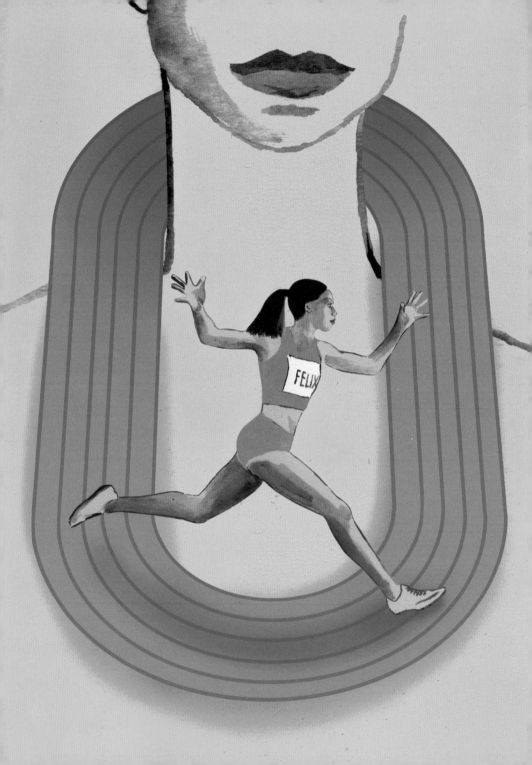

ALLYSON FELIX

LUCKY CHARM NECKLACE

Track and field superstar Allyson Felix is a world champion sprinter with nine Olympic medals under her belt. While racing, she wears a lucky cross necklace given to her by her mom, who she says is an amazing supporter. Felix recalls that her mother gave her the necklace in 2004, for her first Olympics, and she has worn it during every competition since then.

ANNA WINTOUR

TENNIS EVERY MORNING

Editor in chief of *Vogue* magazine Anna Wintour begins every day with a very early morning match of rigorous tennis for one hour. Wintour is not only a focused player but also an avid fan of the game, and she can often be spotted courtside at the U.S. Open and Wimbledon. Her discipline and focus have served her well: she has been editor in chief of *Vogue* since 1988 and was named artistic director of Condé Nast in 2013. She is an arbiter of fashion and one of the industry's most iconic figures.

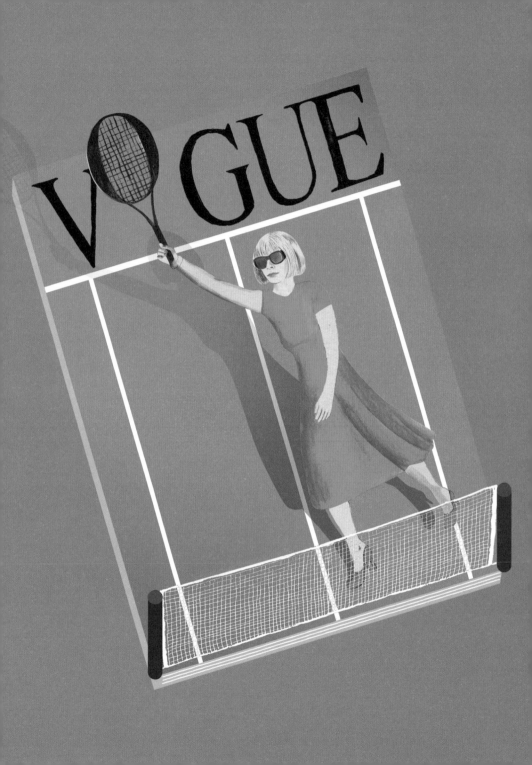

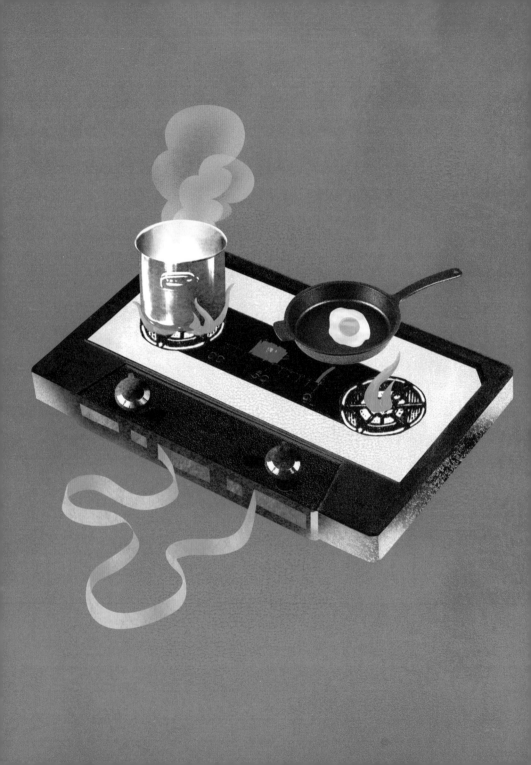

ANTHONY BOURDAIN

PUNK CLASSICS

Chef, author, and TV personality Anthony Bourdain developed a ritual during his days in the kitchen at Les Halles: the go-to soundtrack for his food prep routine featured a collection of mid-'70s New York punk classics. Music has been an essential ingredient in Bourdain's life, and his taste for it began in his childhood, when his father worked for Columbia Records. Over his career, he has hosted four television series and published eight nonfiction books and three novels to date.

AUDREY HEPBURN

LUCKY NUMBER 55

Screen legend, humanitarian, and fashion icon Audrey
Hepburn (1929–1993) had a fascination with the number 55.
She is known to have requested the number for her dress-
ing room—as it had also been her dressing room number for
both of the now-classic films *Roman Holiday* and *Breakfast
at Tiffany's*. Hepburn starred in more than twenty-seven
films over her career, is one of the few actors to earn an
EGOT (an Emmy, Grammy, Oscar, and Tony), and earned a
Presidential Medal of Freedom for her work as a goodwill
ambassador for UNICEF in the 1980s.

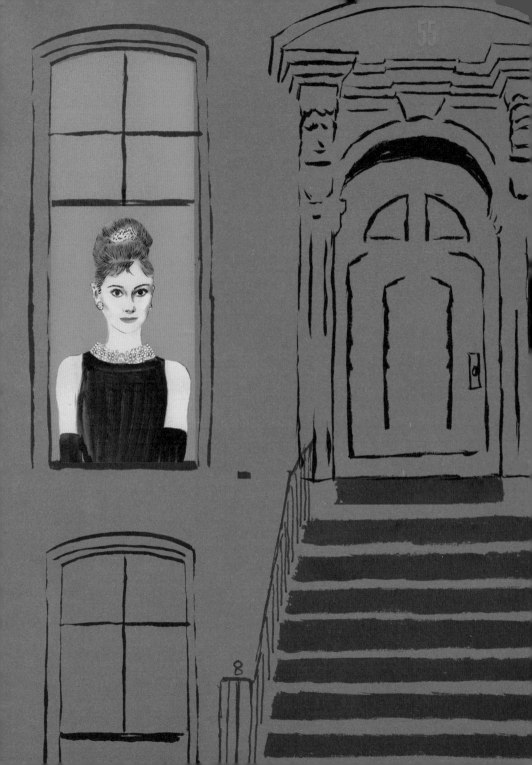

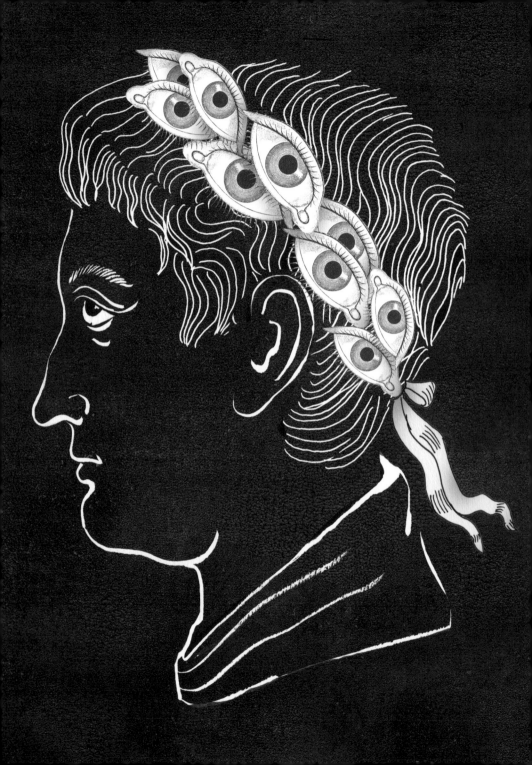

AUGUSTUS CAESAR

FEAR OF THE DARK

Roman emperor Augustus Caesar (63 BC–AD 14) had a fear of sitting in the dark. Known as achluophobia, his fear did not keep him from leading Rome's transformation from republic to empire in the years following the assassination of his great-uncle Julius Caesar. He is credited with nearly doubling the size of the Roman Empire and overhauling every aspect of Roman life during his reign.

BARACK OBAMA

SHOOTING HOOPS

Former U.S. President Barack Obama is a big fan of basketball and loves to play when his schedule allows, especially on the day of an election. During his 2008 primary run against Hillary Clinton, he twice skipped the ritual and lost, and according to his former aide Robert Gibbs, after that, basketball time was not to be missed. Barack Obama won the 2008 primaries and went on to win the 2008 and 2012 elections to serve as the forty-fourth president of the United States.

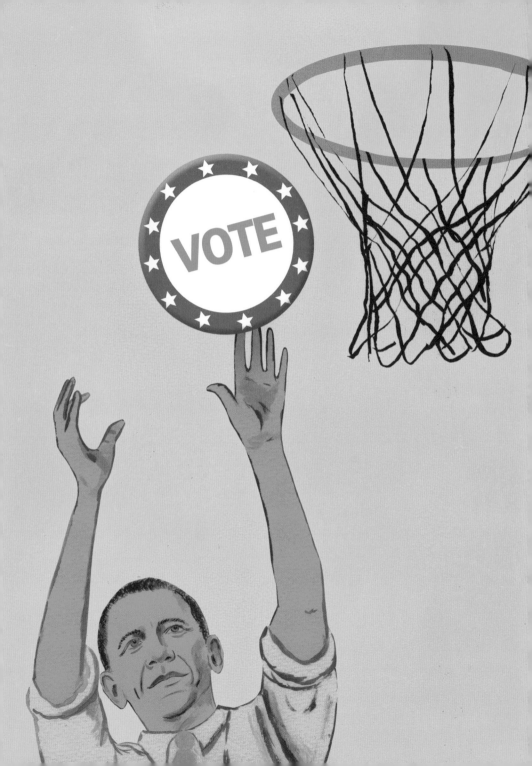

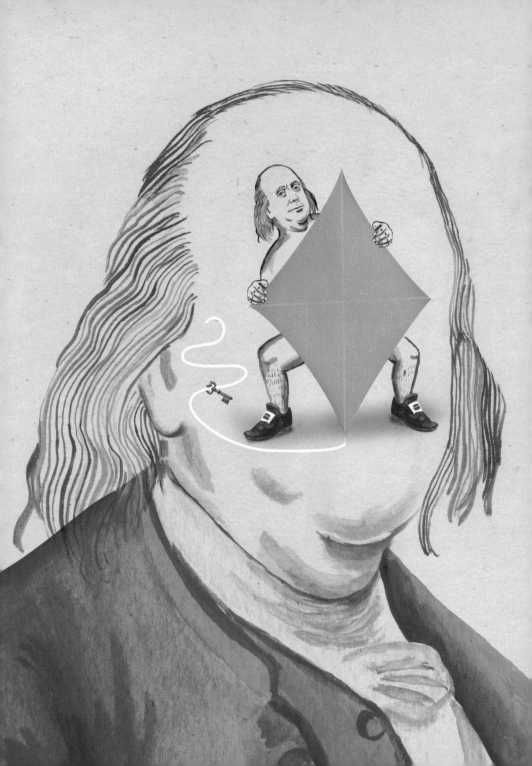

BENJAMIN FRANKLIN

AIR BATHS

Author, inventor, diplomat, and scientist Benjamin Franklin (1706–1790) swore by air baths. Before he started to work, Franklin would sit without any clothes on for a half hour or hour in front of an open window on the first floor of his building. He wrote that the shock of cold water was too violent for him, and it was more agreeable for him to bathe in cold air. Franklin would either read or write during his "bath."

BEYONCÉ

WARM-UP RITUAL THAT LASTS HOURS

Singer-songwriter and performance icon Beyoncé has a
long and elaborate preshow ritual that takes a few hours: it
includes a prayer and stretch with the band, getting her hair
and makeup done in a massage chair, and an hour of peace
while she listens to her favorite playlist. She follows this
routine to ease stress before performing and to help ensure
a great performance, which she is known to deliver. Queen
Bey has earned more than twenty-two Grammy Awards over
her influential career.

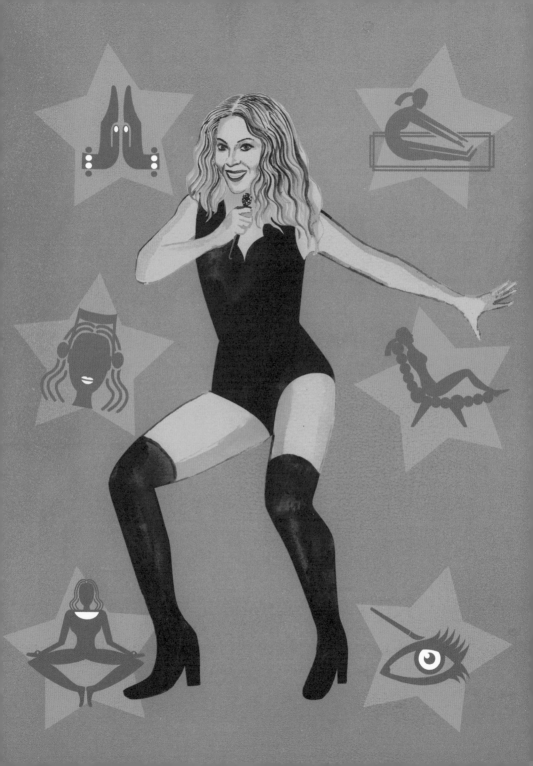

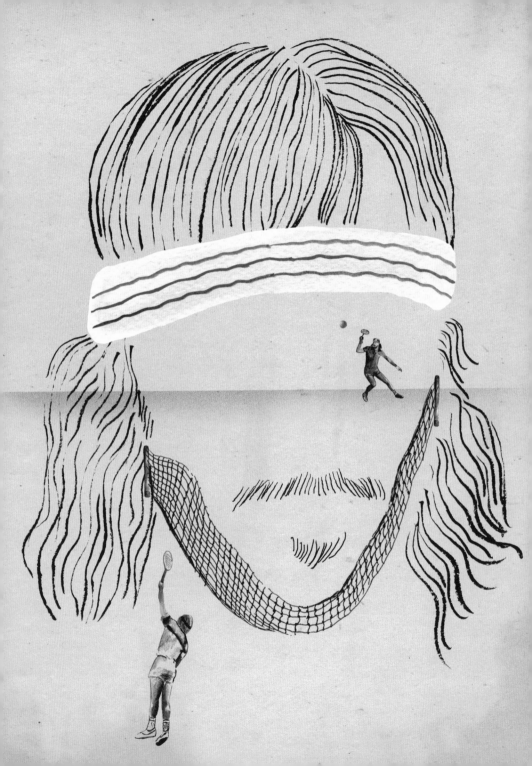

BJÖRN BORG

PLAYOFF BEARD

Tennis great Björn Borg is the first known athlete to have the "playoff beard" superstition. Borg would prepare for Wimbledon by growing a beard and wearing the same Fila shirt for every game. Repeating this ritual may have helped him win five straight Wimbledon titles from 1976–1980. Whether influenced directly or indirectly by Borg's lucky beard and his famed winning streak, athletes in the NFL, NHL, and Major League Baseball have all adopted this practice.

CHARLES DICKENS

SLEPT FACING NORTH

Charles Dickens (1812–1870) carried a navigational compass with him at all times and always faced north while he slept—a practice he believed improved his creativity and writing. The author of such classic novels as *A Christmas Carol* and *Great Expectations*, Dickens was also a social critic guided by a strong moral compass, which he made evident through his incisive depictions of socioeconomic conditions.

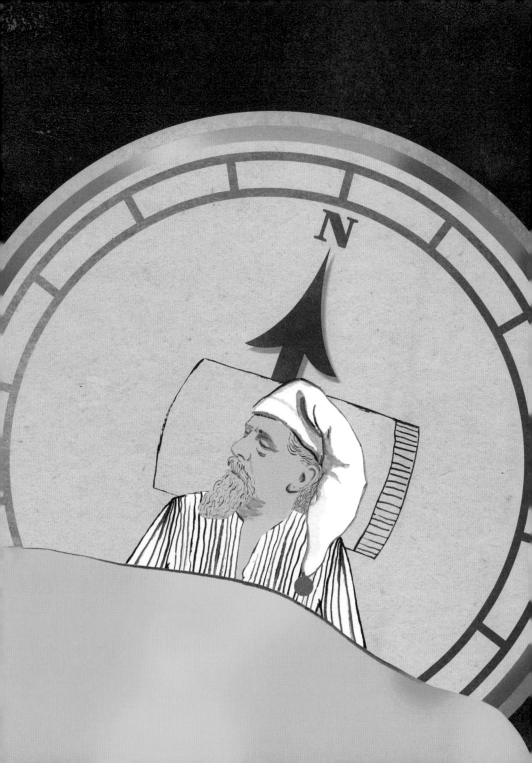

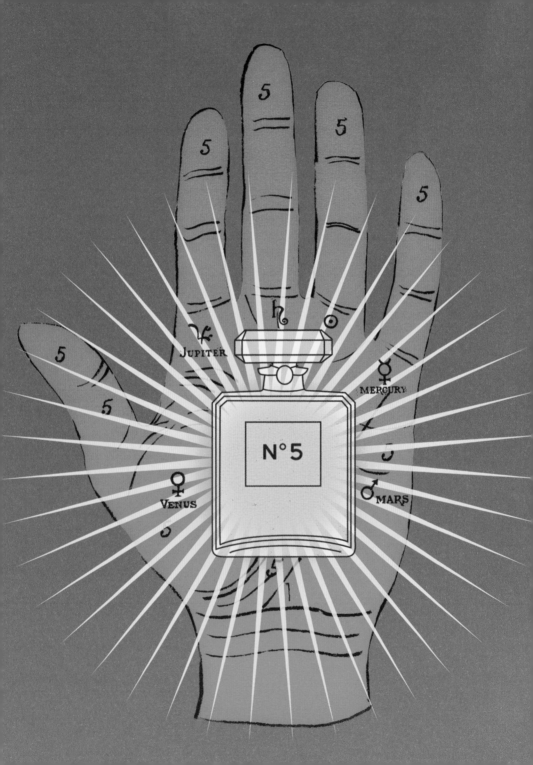

COCO CHANEL

LUCKY NUMBER 5

French clothing designer Coco Chanel (1883–1971) was deeply superstitious. It's been said that she was informed by a fortune-teller that 5 was her lucky number, and she named her famed fragrance accordingly. Her apartment also contained a crystal chandelier created with shapes twisted into the number 5, and she liked to present her collections on the fifth day of May (the fifth month of the year) for good luck.

DAN BROWN

HANGS UPSIDE DOWN

Author of the international bestseller *The Da Vinci Code,* Dan Brown's books have sold more than two hundred million copies worldwide. He uses inversion therapy to inspire suspense: he puts on gravity boots and hangs upside down from a special frame to see things from a fresh angle and shake himself out of writer's block when he gets stuck.

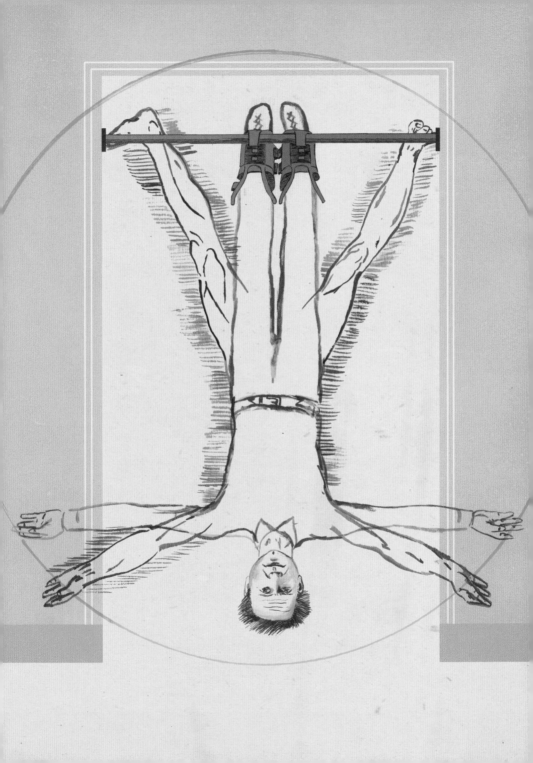

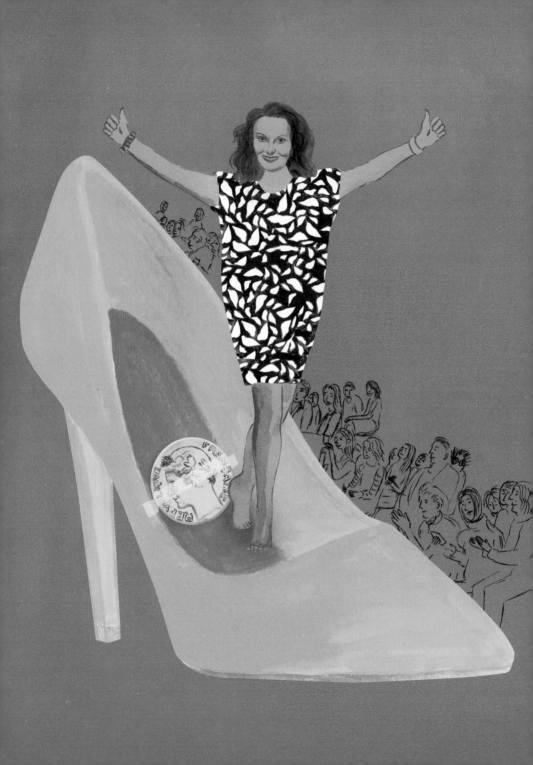

DIANE VON FURSTENBERG

LUCKY GOLD COIN

Fashion designer and icon Diane von Furstenberg has a gold twenty-franc piece her father hid in his shoe during World War II that he gave to her when she was a girl. She tapes the coin in her shoe for good luck before every fashion show. Best known for her iconic wrap dress, von Furstenberg's influential designs are available in more than fifty-five countries worldwide.

DR. SEUSS (THEODOR SEUSS GEISEL)

WORE A HAT WHEN BLOCKED

Author and illustrator Theodor Seuss Geisel (1904–1991), better known as Dr. Seuss, kept an immense collection of nearly 300 hats. When facing writer's block, the place Dr. Seuss would go was his secret closet, where he would choose a hat to wear until he felt inspired. His whimsical habits helped him create some of our most popular children's books—including the classic *The Cat in the Hat*.

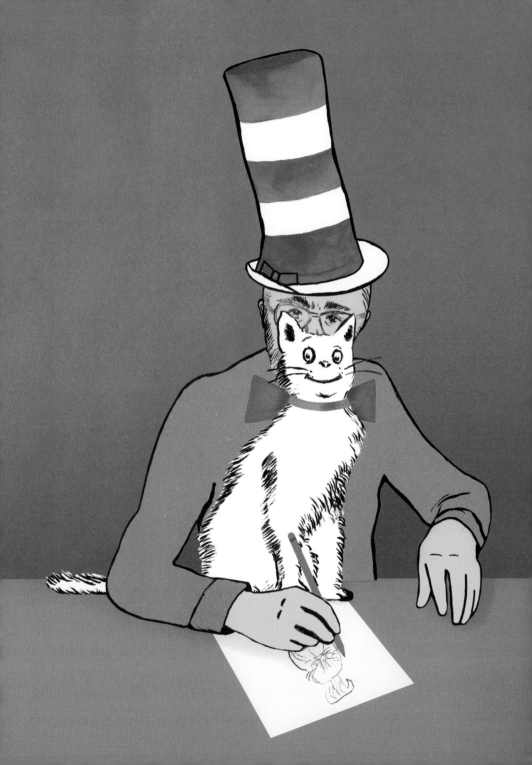

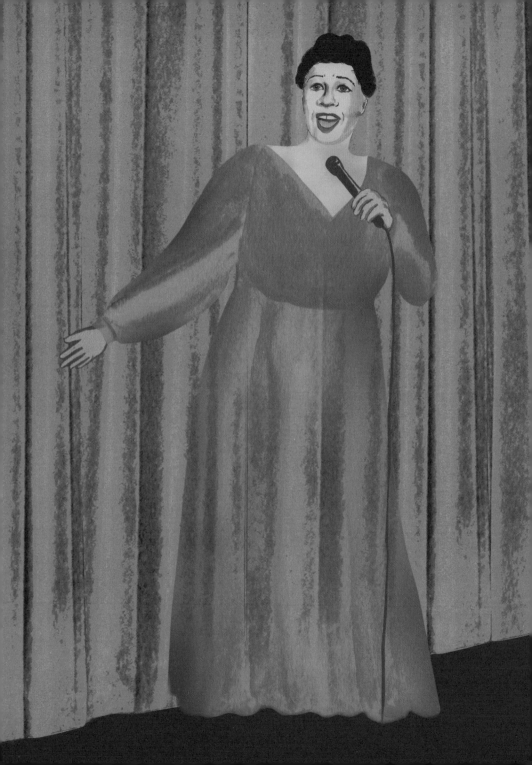

ELLA FITZGERALD

SAME SPOT ON THE STAGE

American jazz singer Ella Fitzgerald (1917–1996) suffered from stage fright. Jazz historian and musician John Chilton, who played alongside her band, recalled that Ella would go through a sequence of movements on the same spot onstage prior to every performance in what appeared to be a ritual, which he believed calmed her enough to perform. The show did go on: Ella is often referred to as the First Lady of Song, and among the many accolades she acquired over her career were the Grammy Lifetime Achievement Award and a U.S. Presidential Medal of Freedom.

ELLEN DEGENERES

MINT THROW

Talk show host and comedian Ellen DeGeneres throws a mint in the air and catches it in her mouth before beginning the opening monologue of her daytime talk show, *Ellen*, which has earned her twenty-eight Daytime Emmy awards to date. DeGeneres says she likes to have minty fresh breath for dancing in the aisles at the start of the show and for occasional kisses with guests such as Matt Damon and Colin Farrell.

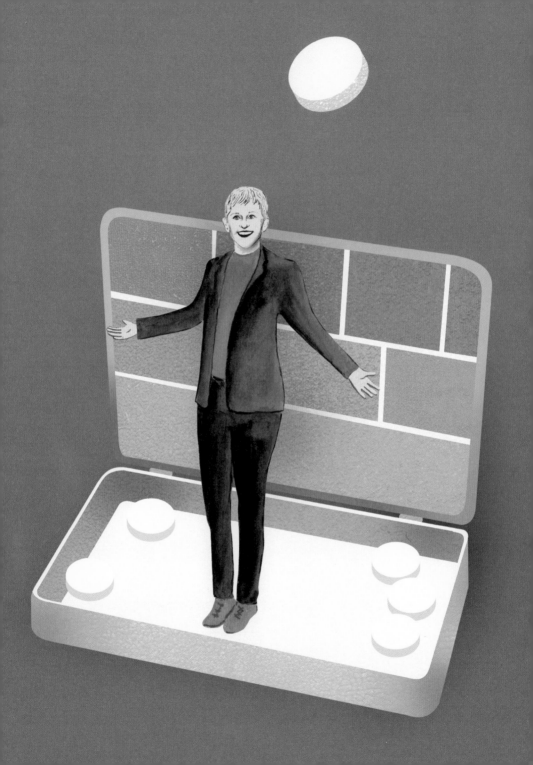

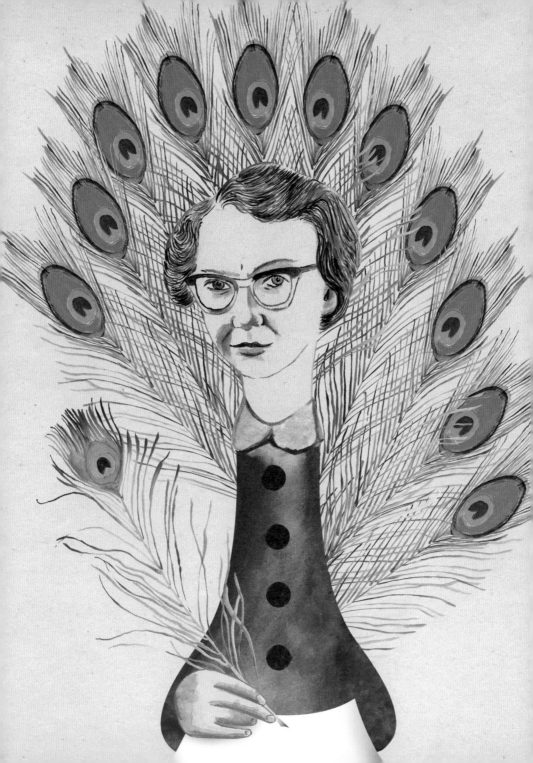

FLANNERY O'CONNOR

PARTY OF PEACOCKS

Author Flannery O'Connor (1925–1964) wrote amidst a party of peacocks, which populated her home, backyard, and her fiction. By O'Connor's estimate, she kept as many as forty peacocks at one point, and described the peacock's cry in her short story "The King of Birds." She wrote: "To me it has always sounded like a cheer for an invisible parade."

FRANKLIN D. ROOSEVELT

TRISKAIDEKAPHOBIA

President Franklin D. Roosevelt (1882–1945), who said, "The only thing we have to fear is fear itself," in his inaugural address, had a fear of his own. He suffered from triskaidekaphobia, a fear of the number 13. He did not like to dine with thirteen guests and some say he would not travel on the thirteenth day of any month. Roosevelt was elected president four times and did not let fear hold him back from guiding the nation through both the Great Depression and World War II.

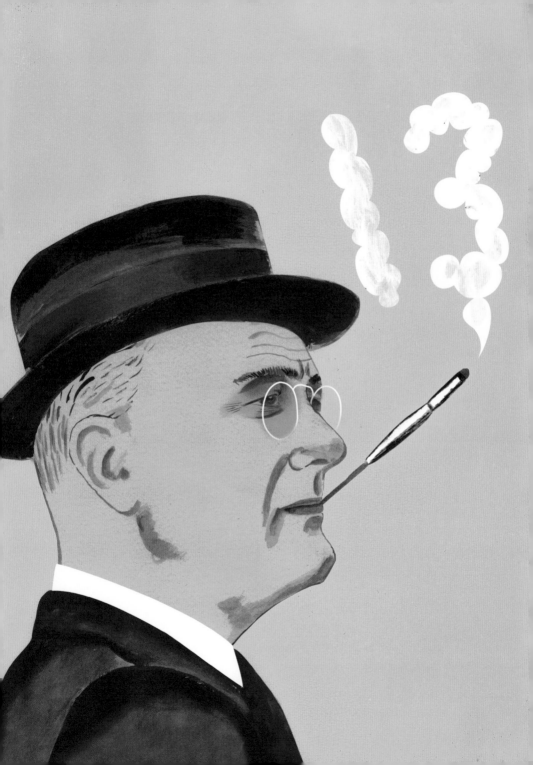

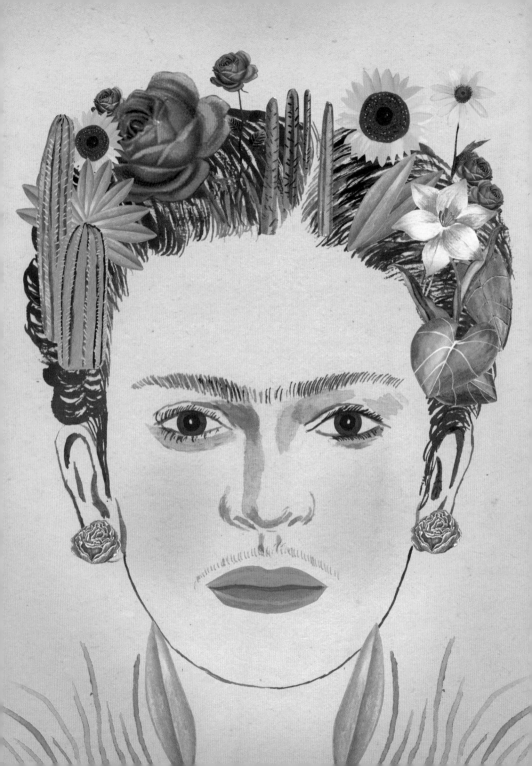

FRIDA KAHLO

HABITUAL GARDENER

Mexican painter and icon Frida Kahlo (1907–1954) created with plants as well as paint as her routine practice. Frida Kahlo's paintings, often autobiographical, are filled with plants and flowers she grew herself in the garden of the home she shared with artist Diego Rivera, known as Casa Azul. Kahlo's well-tended garden was a place of comfort and inspiration for Kahlo and one where she would spend hours tending plants, fruit, and flowers, many of which were of Mexican origin. Kahlo's painting desk looked out at the garden from her window, and her last request when she returned home from the hospital before she died was for her bed to be moved to face her garden.

GABRIEL GARCÍA MÁRQUEZ

NEWS BEFORE WRITING FICTION

Originally a news journalist prior to becoming a novelist, Gabriel García Márquez (1927–2014) would wake before dawn every day and read the newspapers before he would begin writing. His form of magical realism—for which he earned the Nobel Prize in Literature in 1982—was rooted in the real. After working as a reporter for a Colombian newspaper he began writing and selling stories to make money. Eventually these stories bloomed into such novels as *Love in the Time of Cholera* and *One Hundred Years of Solitude*.

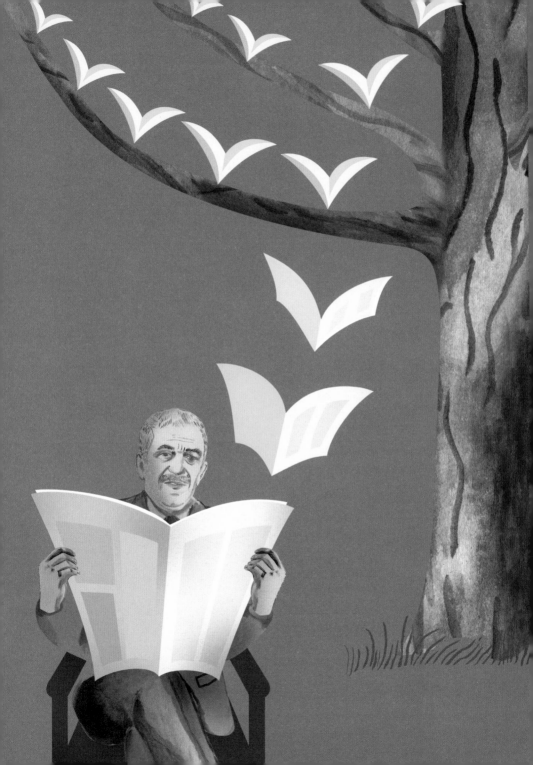

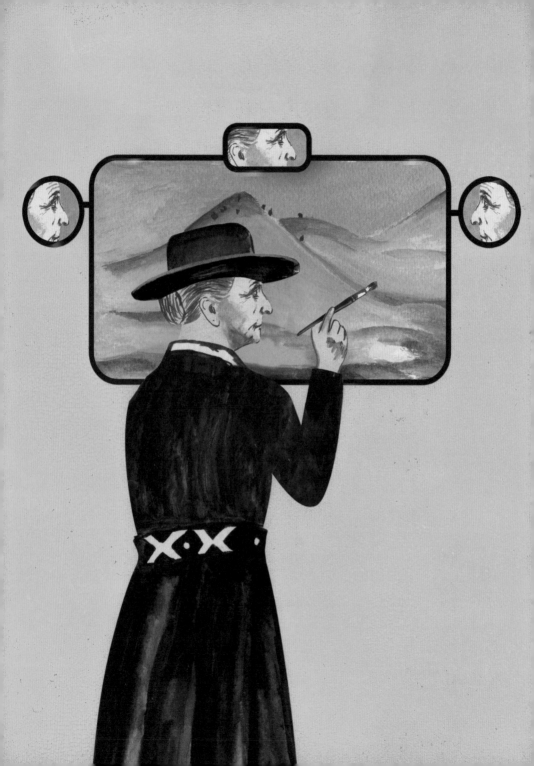

GEORGIA O'KEEFFE

PAINTED IN CAR STUDIO

Painter Georgia O'Keeffe (1887–1986) is often referred to as the Mother of American Modernism. She had a mobile painting studio in her Ford Model A where she would remove the passenger seat, unbolt the driver's seat, and turn to face the back seat, which she utilized as an easel, and paint. O'Keeffe made the first of many trips to New Mexico in 1917, and the region's landscape and adobe architecture were a source of inspiration to her.

GERTRUDE STEIN

PARKED CAR OFFICE

American author Gertrude Stein (1874–1946), who lived in
Paris, had a particular place she liked to write: in her parked
Ford Model T. Stein took full advantage of her time in the
car during trips through the city. While her partner, Alice B.
Toklas, ran errands, Stein stayed back to write, allowing her
surroundings to inspire her—a method that may have influ-
enced the modernist writing approach for which she's
so well known.

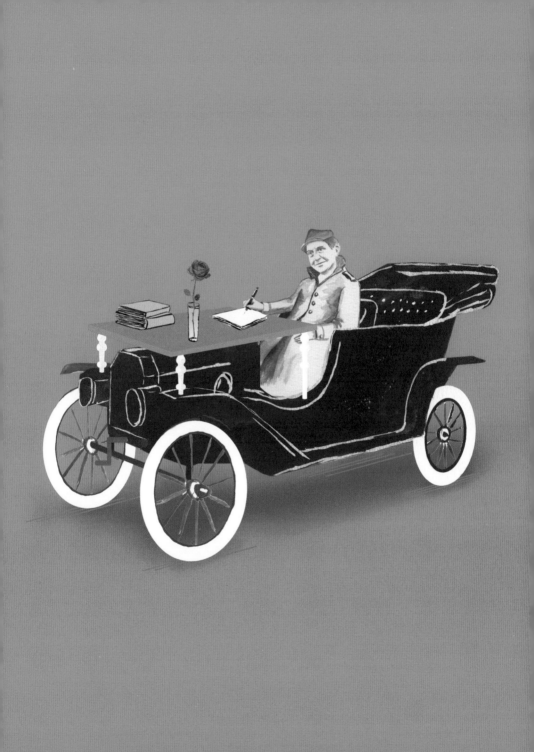

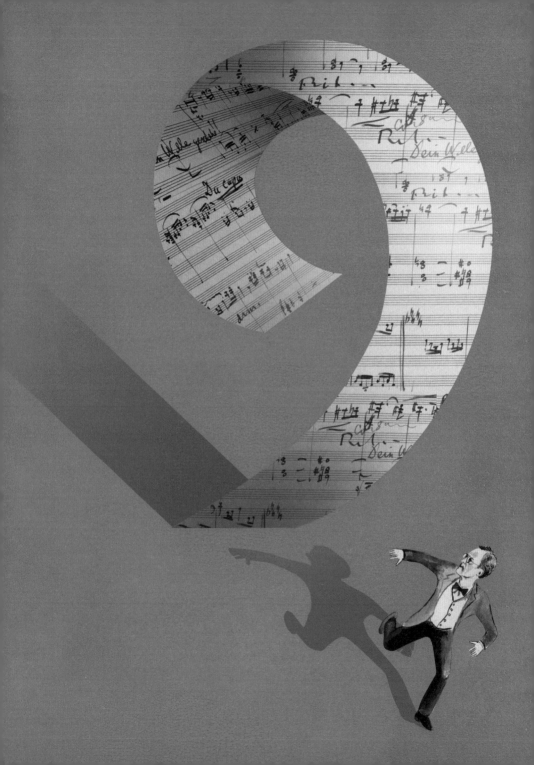

GUSTAV MAHLER

UNLUCKY NUMBER 9

Austrian composer and conductor Gustav Mahler (1860–1911)
was hesitant to name his ninth symphony by number and
called it *Das Lied von der Erde* instead. This was because
several other composers, including Beethoven and Schubert,
died after completing their ninth symphonies. According to
his wife, Mahler had a heart condition and thought he could
cheat death by not naming a symphony "the ninth."

GUSTAVE EIFFEL

FEAR OF HEIGHTS

At the time it was built, the Eiffel Tower was the world's tallest structure, and it remains one of our most iconic. Ironically, Gustave Eiffel (1832–1923), its architect and designer, is said to have secretly harbored a fear of heights.

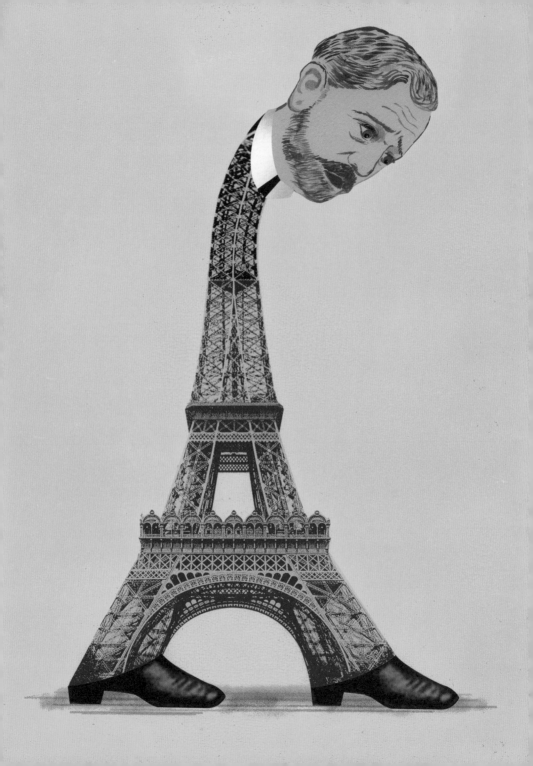

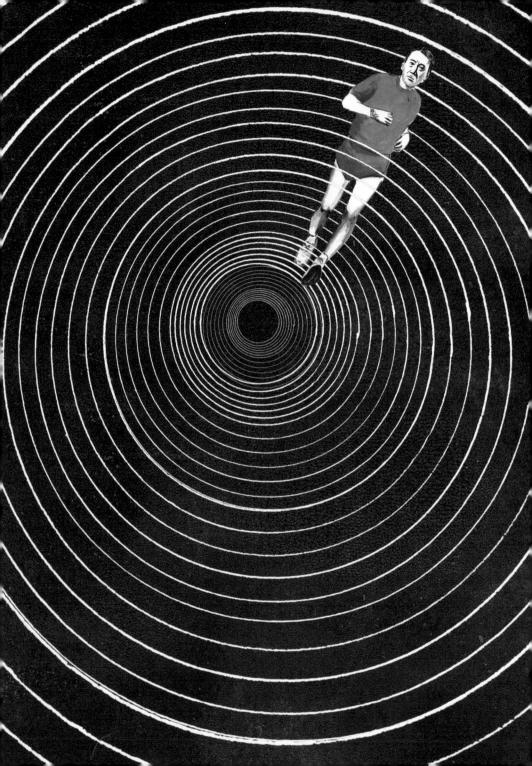

HARUKI MURAKAMI

RUNNING AND WRITING

Acclaimed Japanese author Haruki Murakami is a disciplined athlete as well as writer. Running and exercise are an integral part of his daily routine, which can include waking up as early as 4 a.m. and going to bed as early as 9 p.m. Running helps to calm his mind and gets him into the mesmerized state he needs to be in for his writing.

HEIDI KLUM

BABY TEETH

Supermodel, TV star, and Victoria's Secret spokeswoman Heidi Klum has been known to keep an unusual memento from childhood for good luck: a pouch with her own baby teeth in it. Klum has recalled dropping her pouch on an airplane and having to explain she was looking for her teeth on the floor.

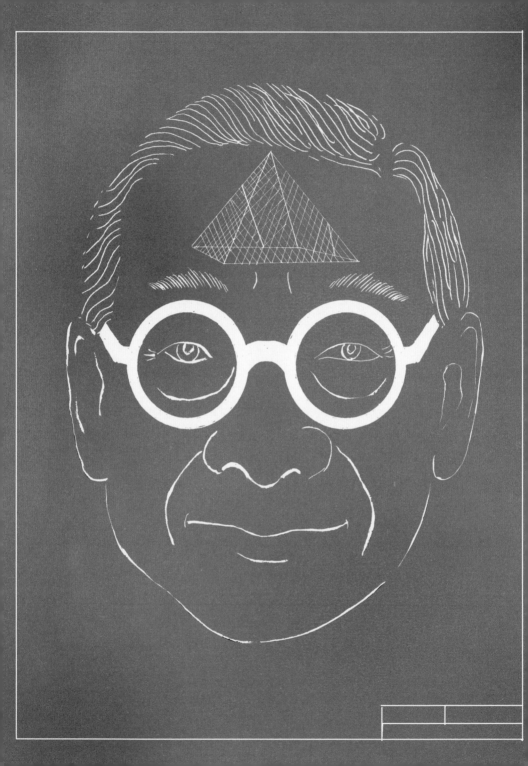

I. M. PEI

DRAWS IN HIS MIND

Architect I. M. Pei has designed more than fifty projects around the world, including the Louvre's glass pyramid, the National Gallery of Art's East Building in Washington, D.C., and the Museum of Islamic Art in Qatar. His unique process relies less on drawing on paper and more on drawing in his mind. He does his best thinking at night in bed with the lights turned off, visualizing the form and space of a structure. Pei said that, periodically, he would go back and forth multiple times in the night to sketch ideas in the bathroom with the light on and then return to the darkness to refine his thinking.

ISABEL ALLENDE

STARTING DATE

Chilean-American author Isabel Allende began writing her first novel on January 8, 1981. What had started as a letter to her grandfather who was dying eventually transformed into *The House of the Spirits*. Allende now begins all of her books on that same day, January 8—initially out of allegiance with the critical and commercial success of her first book. But now, she says, she does it because she can be in solitude, since everyone knows she is not to be disturbed on that date.

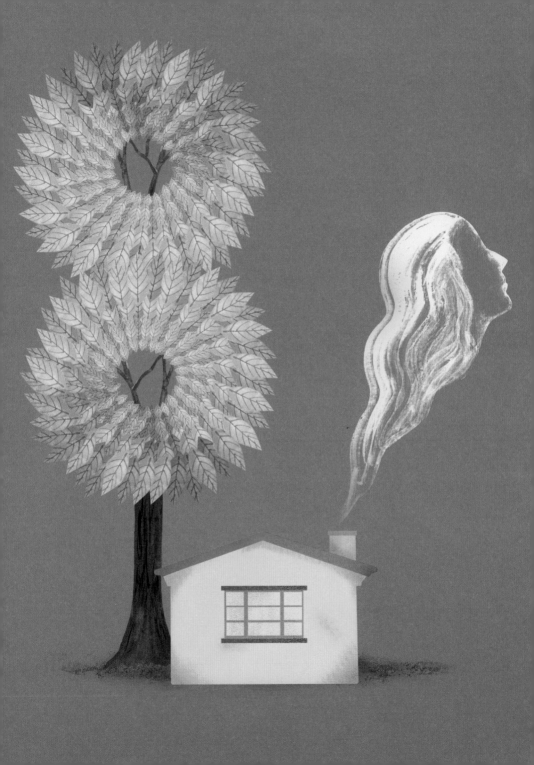

JAMES JOYCE

AUSPICIOUS NUMBER 2

Irish novelist James Joyce (1882–1941) was nervous about a poor response to his epic novel, *Ulysses*, which he had worked on intensely. He chose his birthday, 2/2/1922, as the day to publish his masterpiece. Two copies of the book arrived in Paris by train on this day, one for Joyce and one for his bookseller, Shakespeare and Company. Lucky number 2 worked well for Joyce: *Ulysses* is now such a classic that its legacy is celebrated internationally every year on June 16, in an annual event named Bloomsday, the day that the novel takes place.

J. K. ROWLING

TITLE PAGE LAST

Bestselling author of the Harry Potter series J. K. Rowling will only type her title page once the entire book she is writing is finished. The superstitious practice appears to be working for her: the Harry Potter series is one of the most popular book and film franchises ever.

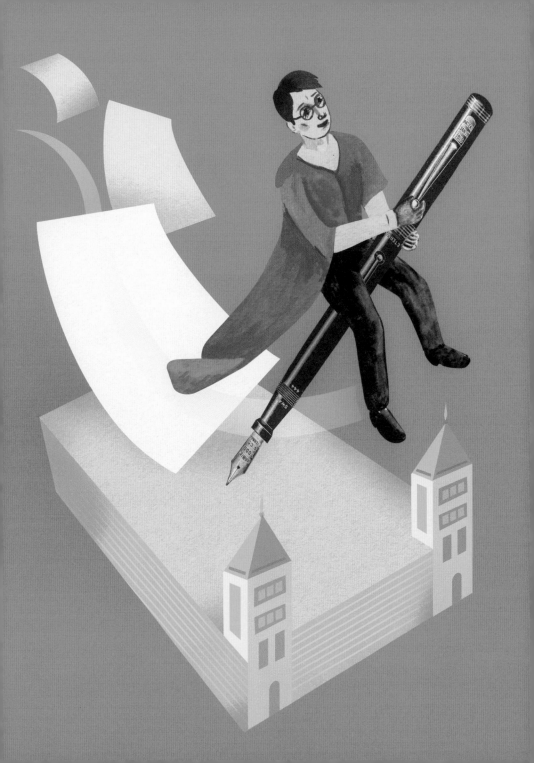

JOAN DIDION

SLEEPS NEXT TO MANUSCRIPT

Author and essayist Joan Didion has a distinctive practice while writing: she sleeps with her manuscript in the same room when she's close to finishing a book. In her own words, she feels "the book doesn't leave you when you're asleep right next to it."

JOHN STEINBECK

TWO DOZEN PENCILS

John Steinbeck (1902–1968), author of such classics as *The Grapes of Wrath*, *East of Eden*, and *Of Mice and Men*, liked to write his drafts in pencil. He always kept exactly two dozen perfectly sharpened pencils on his desk, and he was very particular about the brand of pencils and how they were sharpened. His to-the-point writing technique resulted in a large body of work, which earned him a Nobel Prize in Literature and a Pulitzer Prize.

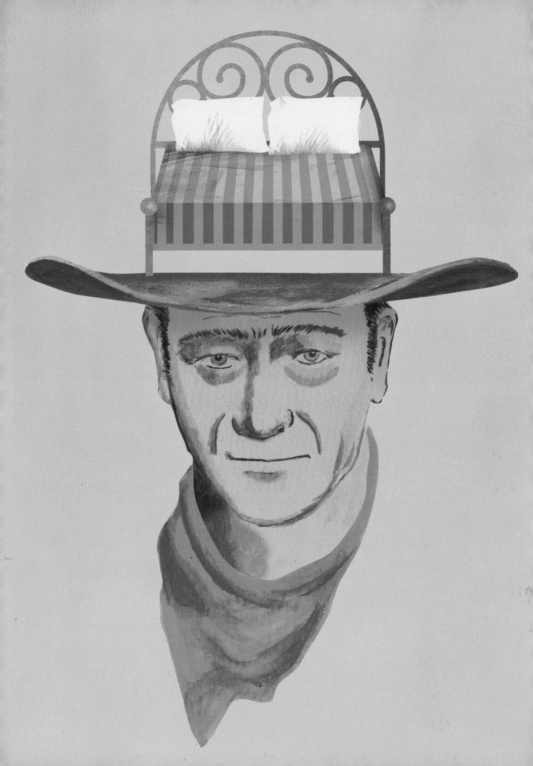

JOHN WAYNE

NO HAT ON THE BED

Legendary Western movie star John Wayne (1907–1979) was rarely seen in his films without a cowboy hat. Offscreen, his temper would flare if someone left a hat on top of the bed, which he considered to be bad luck. According to his daughter, Wayne was deeply superstitious and to him, a hat on the bed would equal unemployment.

LABORATORY OF THE UNIVERSITY OF GEORGIA

LUCKY SOMBRERO

The research lab at the University of Georgia has a "purification sombrero" left behind by a former student who was wearing it when he isolated a critical protein in an experiment. The student had been unsuccessful for two years with his research, but after receiving the sombrero at a birthday celebration, he had the breakthrough he needed. Today students wear the sombrero for good luck with their experiments.

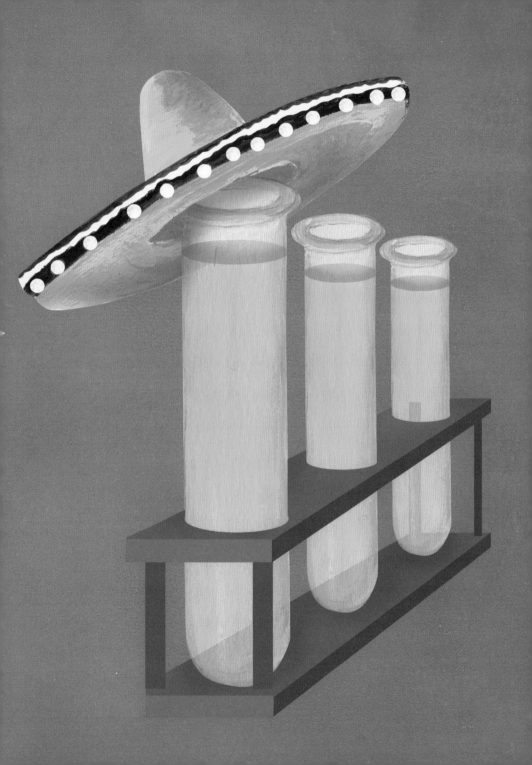

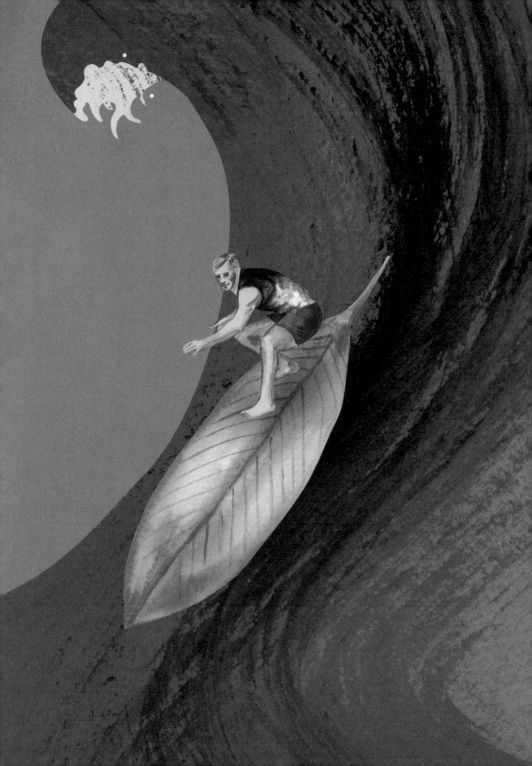

LAIRD HAMILTON

TI LEAF

Champion big-wave surfer Laird Hamilton brings a Hawaiian ti leaf with him when surfing giant waves because he believes it will carry him back to shore—an homage to the practice of ancient Polynesians, who brought ti leaves on their seafaring voyages for good luck.

LEONARD COHEN

CHANTED IN LATIN PRESHOW

Canadian songwriter, musician, and poet Leonard Cohen
(1934–2016) had a unique ritual before his concerts. He
would gather his band together before entering the stage
and lead them in a song in Latin: "*Pauper sum ego, nihil habeo*"
(I am poor, I have nothing). His backup singers recalled that
it was a great way to focus before a performance and unified
them as a group.

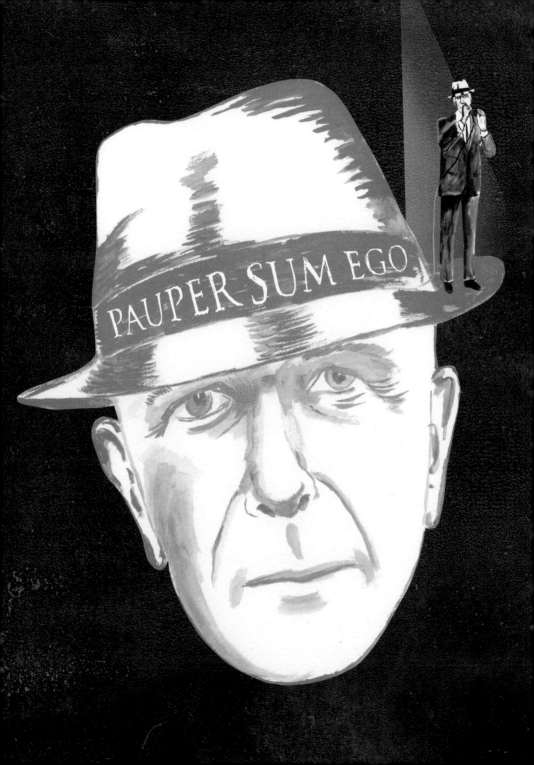

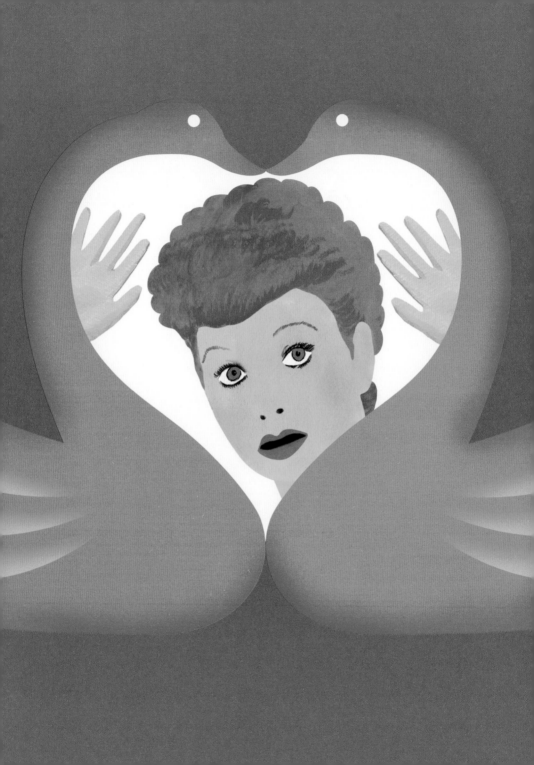

LUCILLE BALL

FEAR OF BIRDS

Comedian and TV icon Lucille Ball (1911–1989) was not only
the star of *I Love Lucy* and several other hit sitcoms, she was
a TV executive, producer, and the first woman to run a TV
production company. She also had a deep fear of birds. When
Lucy was just three years old, her father died on the same day
that a bird had flown into and became trapped in her house—
and her fear developed after that tragedy. She refused to stay
in hotels that had bird wallpaper or pictures of birds on the
walls, and the stagehands on *I Love Lucy* were told to never
place porcelain birds on the set.

LUDWIG VAN BEETHOVEN

COUNTED COFFEE BEANS

Master composer Ludwig van Beethoven (1770–1827) rose at dawn and would immediately get to work. According to his secretary, coffee was the most important item in his diet, and he prepared it very methodically, counting out sixty coffee beans per cup. His routine sustained nine symphonies, thirty-two piano sonatas, and an opera over his lifetime.

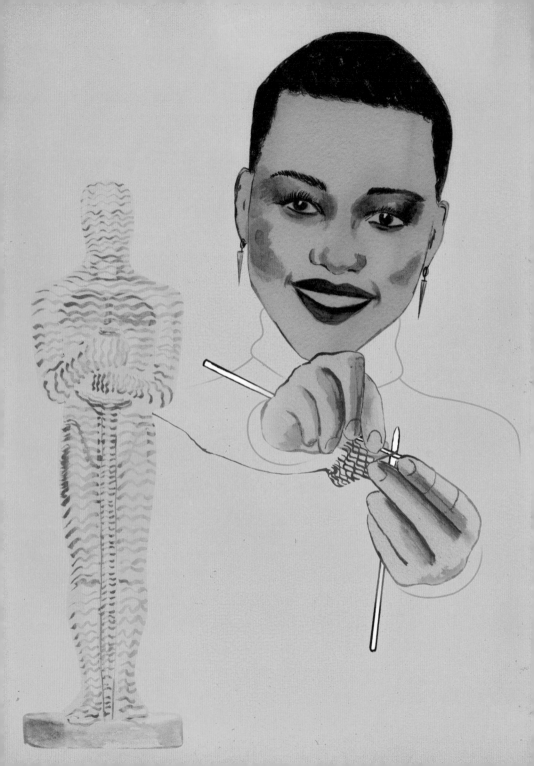

LUPITA NYONG'O

KNITTING BEFORE PERFORMANCE

Actor Lupita Nyong'o knitted in her dressing room as part of her preparation ritual before a performance, as she revealed on her Instagram account during her Broadway run of *Eclipsed*. Nyong'o earned critical acclaim for that role and won the Academy Award for best supporting actress for her role in *12 Years a Slave*.

MARIE CURIE

SLEPT WITH A JAR OF RADIUM

Marie Curie (1867–1934) had a close connection with her work that extended beyond the laboratory. So close that she slept with a jar of the radium she helped to discover by her bedside. Curie was a Polish-born French physicist famous for her work on radioactivity and the winner of two Nobel Prizes. She was the first person and only woman to win the prize in two different fields, Physics and Chemistry.

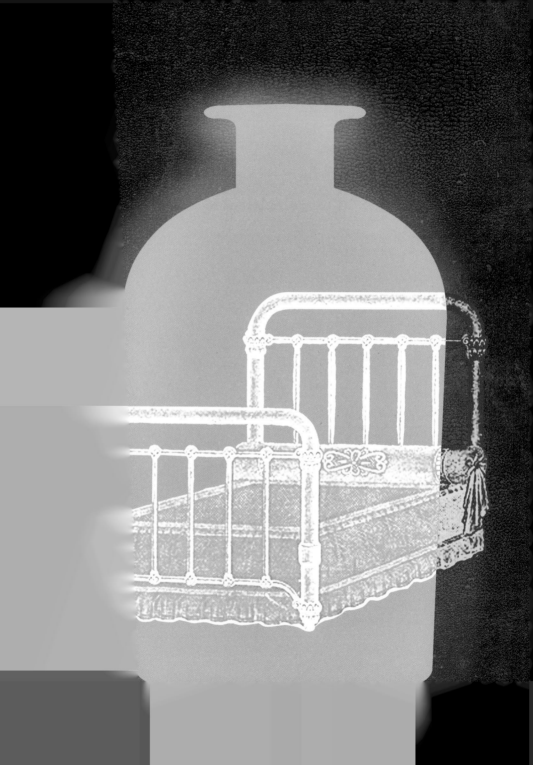

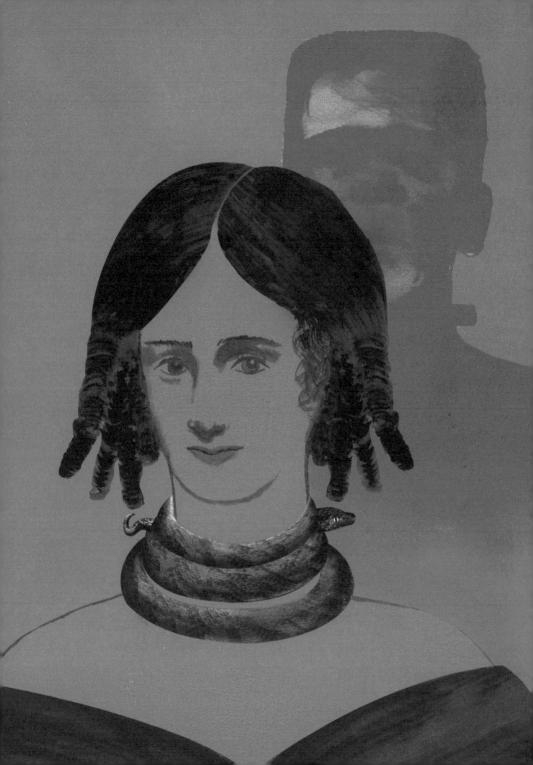

MARY SHELLEY

PET BOA CONSTRICTOR

English romantic novelist and author of the classic *Frankenstein*, Mary Shelley (1797–1851) had a pet boa constrictor who was her writing companion. Allegedly, Shelley wrote with her companion around her shoulders and let the snake's squeezes dictate when to keep working or stop. Her fondness for snakes even found its way into her writing: in her *Rambles in Germany and Italy in 1840, 1842 and 1843*, her last published work, she described the weather as "rain[ing] boa-constrictors."

MAYA ANGELOU

WROTE IN A HOTEL ROOM

Renowned author, poet, and civil rights activist Maya Angelou (1928–2014) would leave her apartment at 6 a.m. and go to a tiny bare hotel room until 2 p.m. to write. The only things she would take with her were a legal pad, a dictionary, Roget's Thesaurus, a Bible, a deck of cards, and a bottle of sherry, and she would ask that the hotel staff remove everything from the walls of her room.

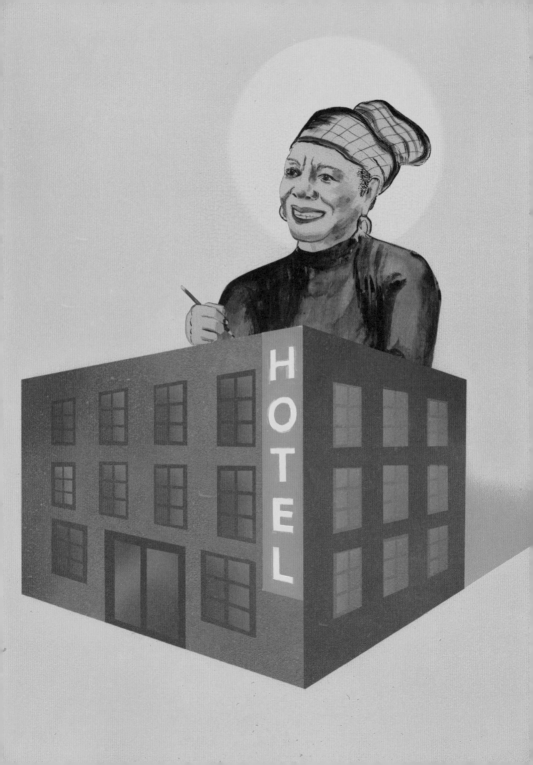

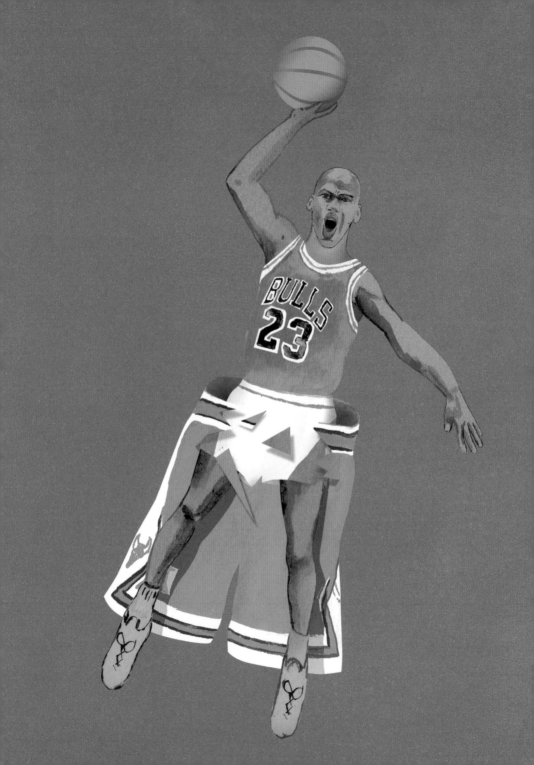

MICHAEL JORDAN

SHORTS UNDER SHORTS

In 1982, basketball superstar Michael Jordan scored the winning jump shot that brought his college team, the University of North Carolina Tar Heels, their first NCAA championship since 1957, and launched his rise to stardom. From that game on and into his days as an NBA player, Jordan wore his UNC shorts for good luck under his Chicago Bulls uniform. He started the trendsetting change from midthigh shorts to longer shorts as a way of covering up his UNC pair that was underneath. Jordan went on to lead the Bulls to six NBA championships, earned the status of MVP five times, and has been inducted into the Basketball Hall of Fame.

MISTY COPELAND

HIP-HOP BEFORE BALLET

Misty Copeland made history when she became the first African-American female principal dancer with the American Ballet Theatre. Listening to music is a crucial part of her preperformance routine. In an interview, the ballet star has professed her love for hip-hop music and how it gets her in the mindset to perform in classics such as *Swan Lake*. Copeland says that she needs music in her system prior to getting on stage.

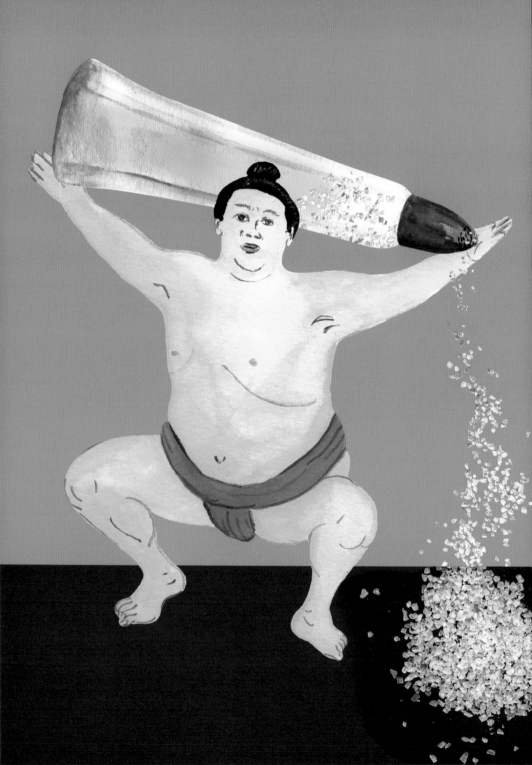

MITOIZUMI

PURIFYING SALT

Prior to a match, sumo wrestlers sprinkle the ring with salt to purify it and ward off evil spirits. Wrestler Mitoizumi had a dramatic ritual of sprinkling salt in such a large quantity that he earned the nickname Saltshaker. At one point, Mitoizumi was asked to curb the amount of salt he dispersed, as it was becoming a hazard for competitors who followed his matches. Mitoizumi won more than eight hundred matches during his two-decade-long career.

NAPOLÉON BONAPARTE

FEAR OF BLACK CATS

Legendary French General and Emperor Napoléon Bonaparte
(1769–1821) consulted with a clairvoyant, Madame Normand,
when he needed advice for his war campaigns, and he
believed that his dreams foretold the future. Before the
Battle of Waterloo, he dreamed of a black cat and took it as
a bad omen. He famously lost the battle but left France and
all of Europe with many reforms—including the Napoleonic
Code, a set of laws concerning property and individual
rights—still of influence today.

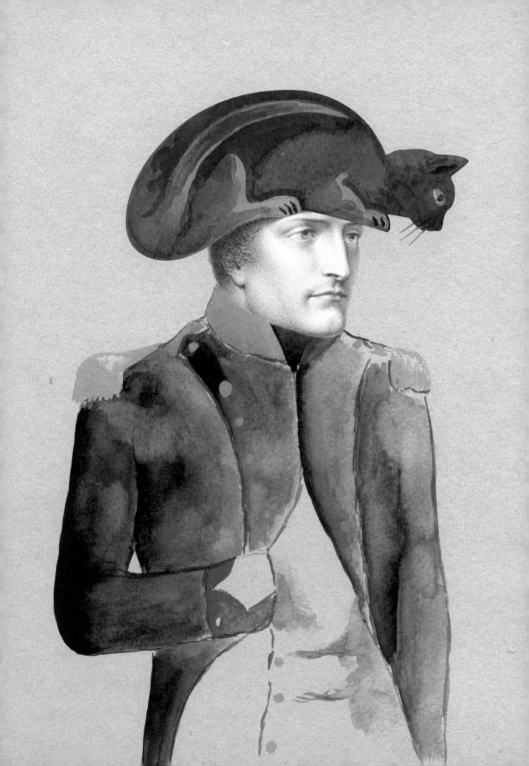

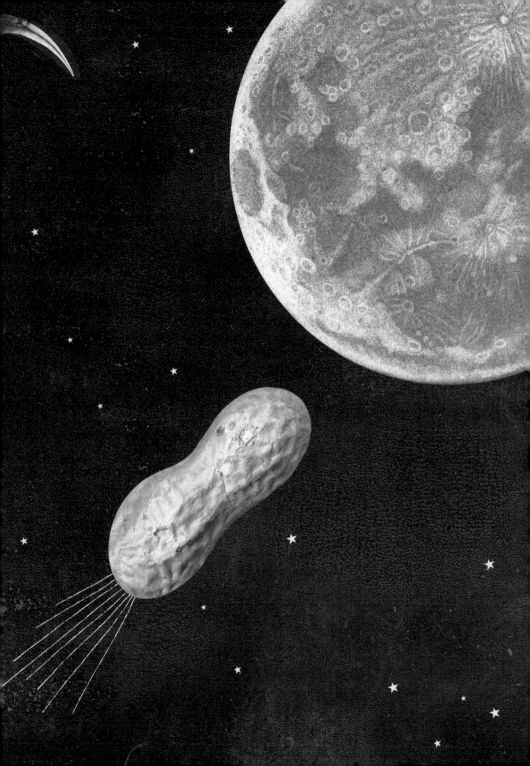

NASA

LUCKY PEANUTS

Even NASA has its good luck charms: NASA's peanut super-
stition originated at the Jet Propulsion Laboratory's Space
Flight Operations Facility in 1964 during the Ranger 7
mission. The previous six missions all failed but during the
seventh attempt, Dick Wallace, mission trajectory engineer,
brought in jars of peanuts and passed them around to the
engineers and scientists to ease prelaunch tension. Ranger
7 was a huge success, as were the missions Rangers 8 and
9, and ever since then, peanuts have been a must-have for
launches. The superstition was reinforced when one space-
craft was lost when the peanuts were not present, and
another launch was delayed for forty days until the lucky
peanuts arrived.

NIELS BOHR

HORSESHOE

Danish physicist Niels Bohr (1885–1962), who won the Nobel Prize for his research on atoms, kept a horseshoe nailed over the door to his laboratory. Although Bohr said he didn't believe the horseshoe to be lucky, he kept it there just in case.

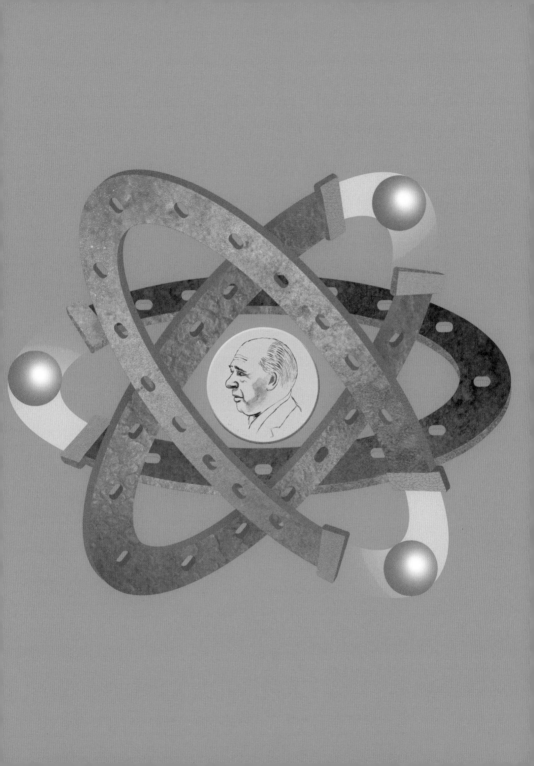

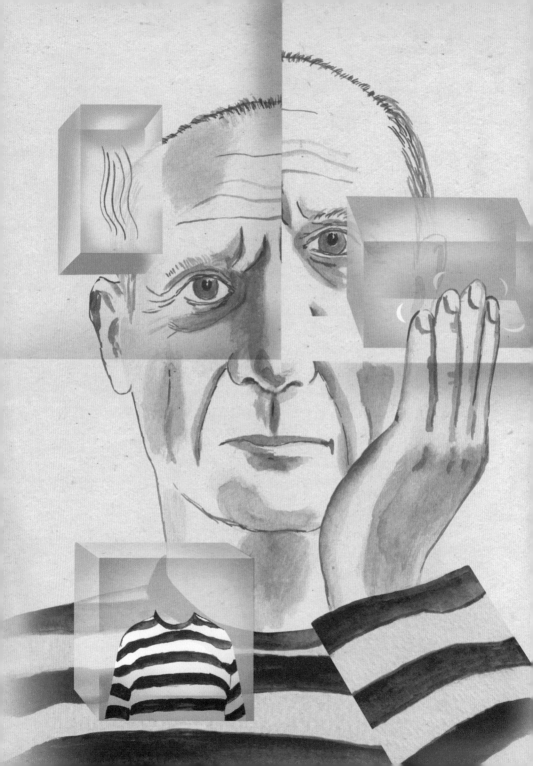

PABLO PICASSO

HELD ONTO HIS "ESSENCE"

Spanish artist Pablo Picasso (1881–1973) would not throw away his old clothes, hair trimmings, or fingernail clippings for fear it would mean losing part of his "essence." Picasso collected Picasso, and at the time of his death, he owned around fifty thousand works of his own, which ranged from prints and drawings to ceramics and theater sets. He is hailed as one of the last century's most prolific and influential artists.

PATRICIA HIGHSMITH

BACON AND EGGS

Patricia Highsmith (1921–1995), author of the psychological thrillers *Strangers on a Train*, *The Price of Salt*, and *The Talented Mr. Ripley*, saved the suspense for her writing by taking the mystery out of her eating habits: according to a friend, she ate fried eggs and bacon for almost every meal.

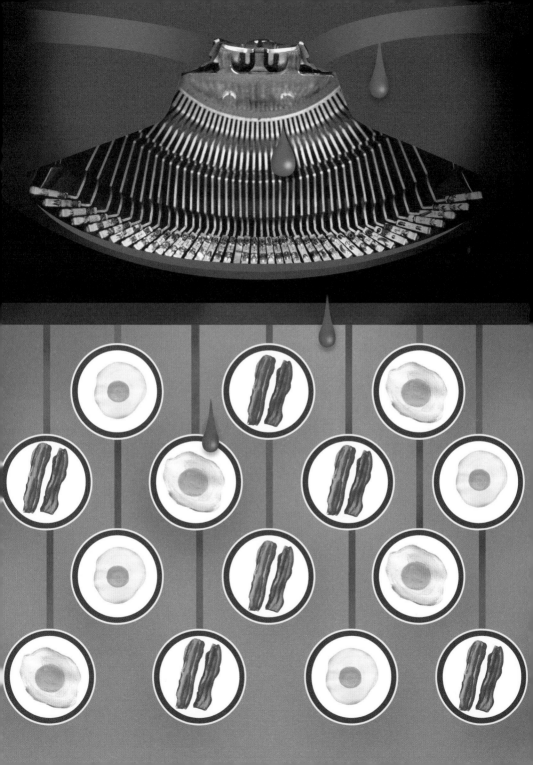

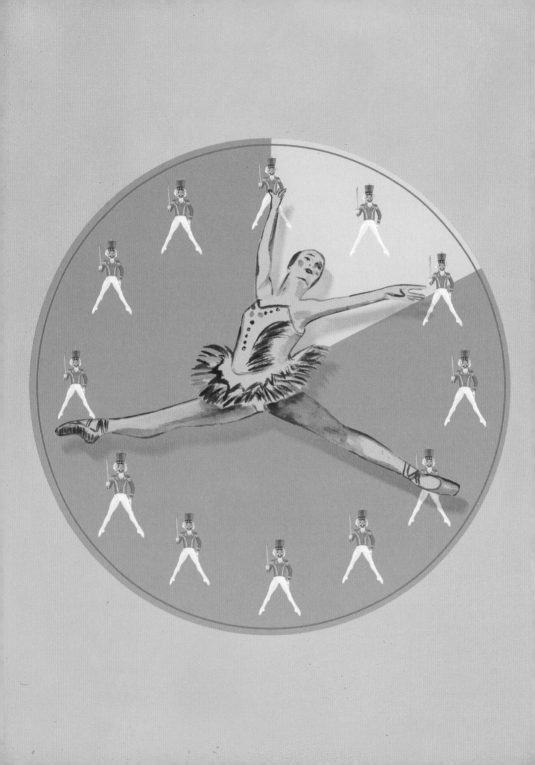

PYOTR ILYICH TCHAIKOVSKY

TWO-HOUR WALK

Russian composer Pyotr Ilyich Tchaikovsky (1840–1893) believed he had to take a walk for exactly two hours every day; he thought that if he returned even a few minutes early, a great misfortune would befall him, according to his brother. Tchaikovsky had read about the importance of a two-hour daily walk to maintain good health, and he took the regimen literally, never returning five minutes too soon or too late. He always walked alone and contemplated compositions while he did, jotting down ideas as he strolled.

ROBERT PLANT

IRONS SHIRTS

While Led Zeppelin's rock-and-roll lifestyle and flamboyant fashion is the stuff of legend, lead singer Robert Plant's preperformance habits today are far less wild. These days, Plant maintains the rather quotidian ritual of ironing his own shirts to get ready to go onstage and requests an ironing board preshow to do so. Plant is considered by *Rolling Stone* to be one of the one hundred greatest singers of all time.

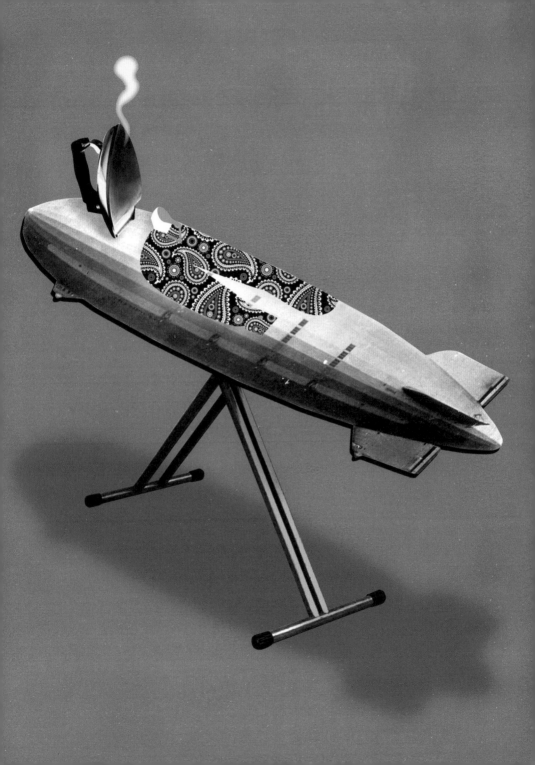

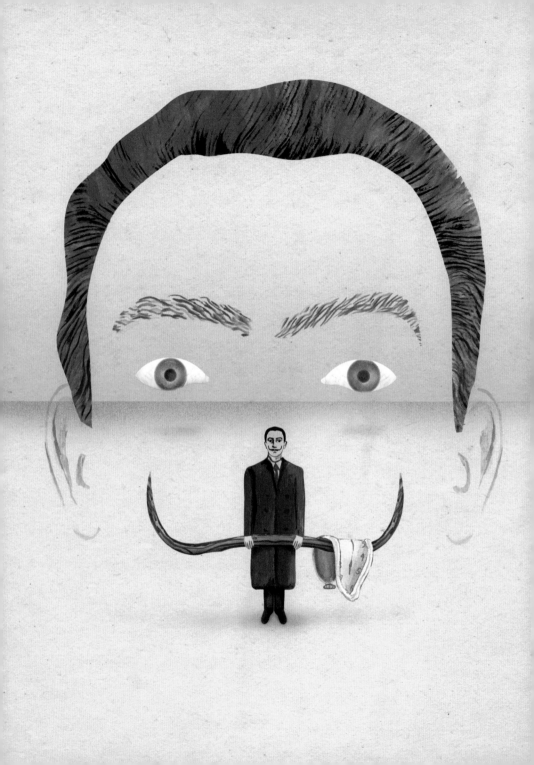

SALVADOR DALÍ

SPANISH DRIFTWOOD

Spanish surrealist painter Salvador Dalí (1904–1989) considered himself to be very superstitious and carried around a little piece of Spanish driftwood to help him to ward off evil spirits. Dalí was a prominent and influential painter whose life and work embraced surrealism. Known for his idiosyncrasies, he nearly suffocated once while giving a lecture in a diving bell helmet and suit.

SERENA WILLIAMS

FOOTWEAR SUPERSTITIONS

Tennis great Serena Williams rules the court with her aggressive playing style and has won a record-breaking number of Grand Slam titles to date. The Olympic medalist has several distinctive preperformance and on-court rituals: prior to a match, she ties her shoelaces the exact same way and reportedly will wear the same pair of socks during a tournament run. She also always bounces the ball five times before her first serve and twice before her second.

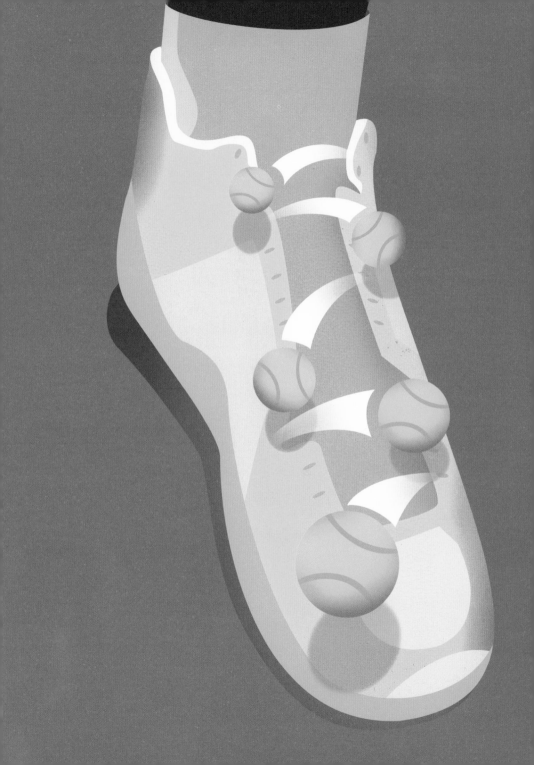

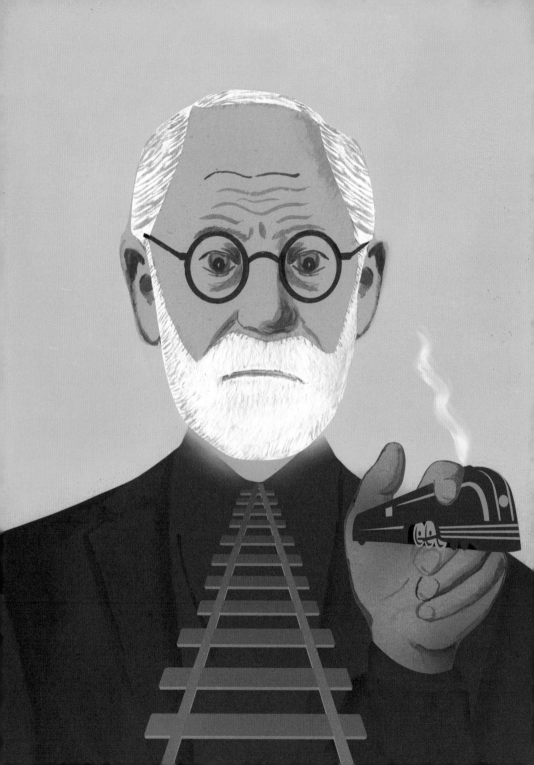

SIGMUND FREUD

FEAR OF TRAIN TRAVEL

Founder of psychoanalysis Sigmund Freud (1856–1939) had a phobia of trains and generally refused to travel in them. His first train trip was from Freiburg to Leipzig, during which he thought he was traveling through hell when he saw gas lamps burning through the train window. His second trip was equally traumatic, but productive: his self-analysis of that ride became the basis for his famed Oedipus complex theory.

TAYLOR SWIFT

LUCKY NUMBER 13

Defying convention, pop star Taylor Swift says 13 is her lucky number. Not only is her birthday on the thirteenth, but according to Swift, her first album went gold thirteen weeks after being released, and she has been seated in either seat 13 or the thirteenth row for every award she has won. Swift has broken records for her album sales, which total over forty million albums around the world.

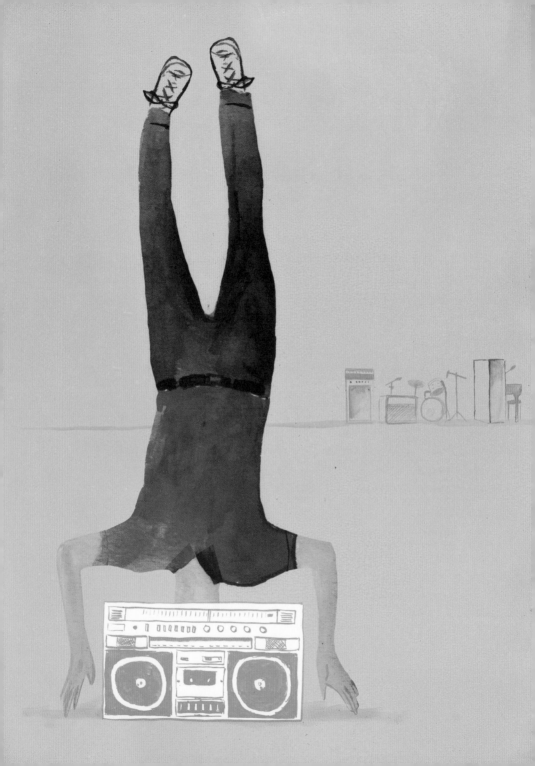

THOM YORKE

HEADSTAND

Radiohead front man Thom Yorke has adopted a preperformance ritual of standing on his head for a few minutes before taking the stage. Yorke has released several solo albums as well as nine albums with Radiohead—two of which have won best alternative music album at the Grammy Awards.

TIGER WOODS

RED SHIRT

Golf champion Tiger Woods has a lucky color: he wears a red shirt on the last day of a tournament and attributes the habit to his mother, who encouraged him to wear red because of its relation to his Capricorn sign. Woods became the first African-American and the youngest golfer to win the Masters Tournament in 1997. He began wearing red shirts in his college days at Stanford for important events and kept up the habit, in his own words, out of superstition.

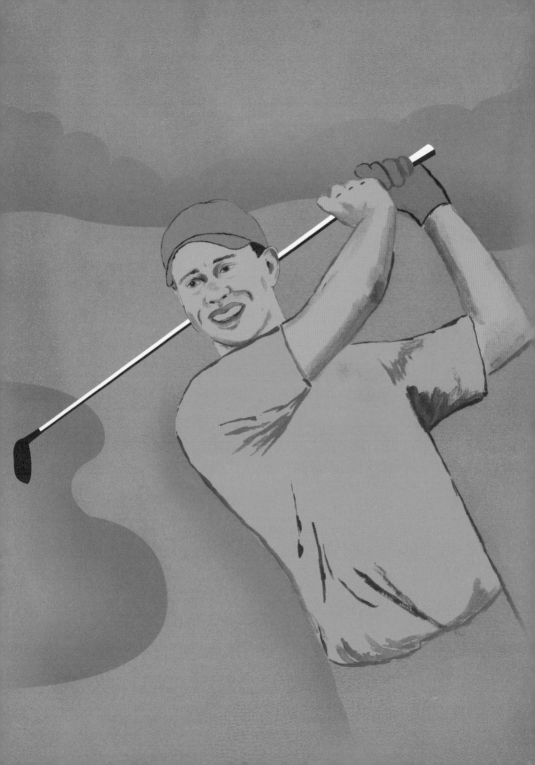

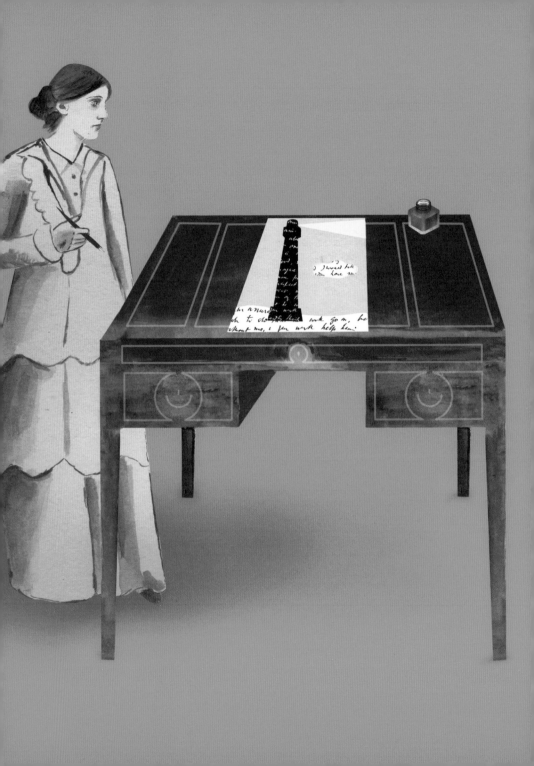

VIRGINIA WOOLF

WROTE AT A STANDING DESK

Regarded as one of the most influential writers of the twentieth century, Virginia Woolf (1882–1941) penned her classics—among them *To the Lighthouse* and *Mrs. Dalloway*—from a standing desk. Like a painter, she preferred to be able to regularly step away from her work to get a different view.

WADE BOGGS

CHICKEN

Wade Boggs was a third baseman with the Boston Red Sox and the New York Yankees. Boggs achieved his 3,010 hits over eighteen years of play with a routine diet of chicken; he consumed the bird before every game, earning him the nickname Chicken Man. Boggs had other pregame routines and superstitions: he always took batting practice at 5:17 p.m. and ran sprints at 7:17 p.m. Wade was inducted into the Baseball Hall of Fame in 2005.

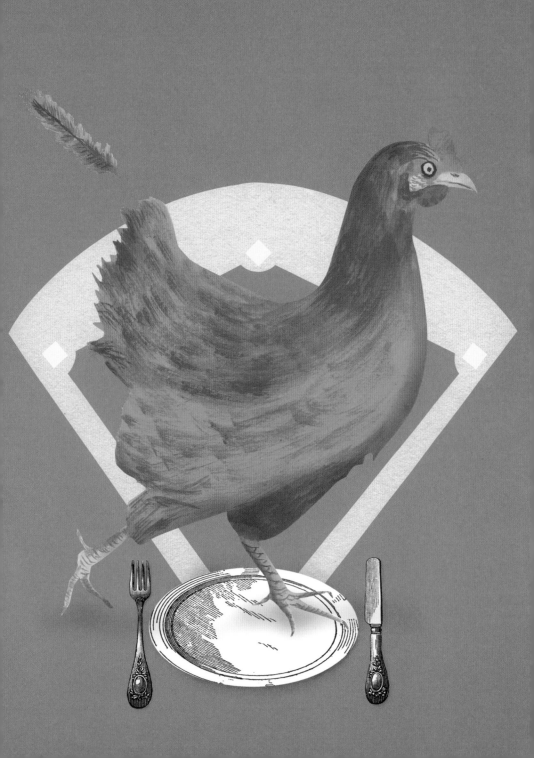

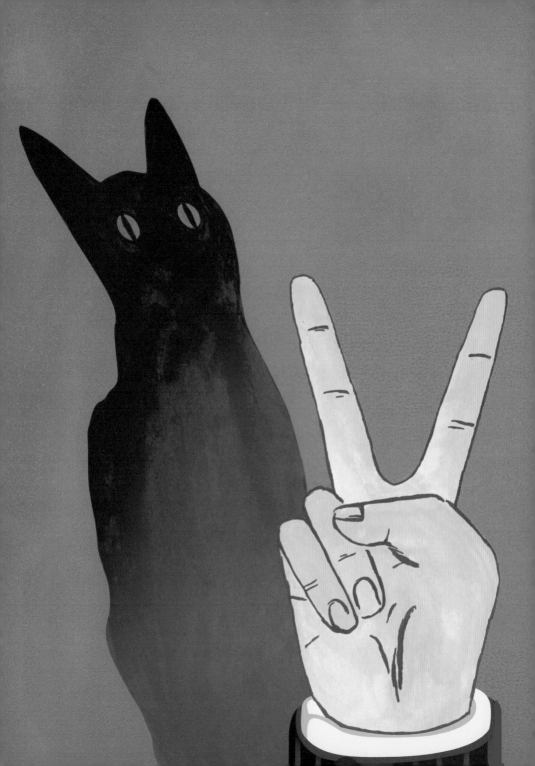

WINSTON CHURCHILL

LUCKY BLACK CATS

British statesman and former prime minister Winston Churchill (1874–1965) was the leader of the British people during World War II and is considered to be one of the most influential politicians of the twentieth century. He was also a cat lover. Allegedly his cat Nelson would attend cabinet meetings to ensure their success, and he petted black cats for good luck.

YOKO ONO

LIGHTING A MATCH

Renowned multimedia artist and peace activist Yoko Ono was very sensitive to sound and light when she was young. Ono discovered that lighting a match and watching the flame extinguish in a dark room gave her a sense of relief. She said she would repeat this ritual, sometimes in front of her sister, continuously until she calmed down. Later this private ritual became a performance piece, called *Lighting Piece*, which was recorded with the collective Fluxus.

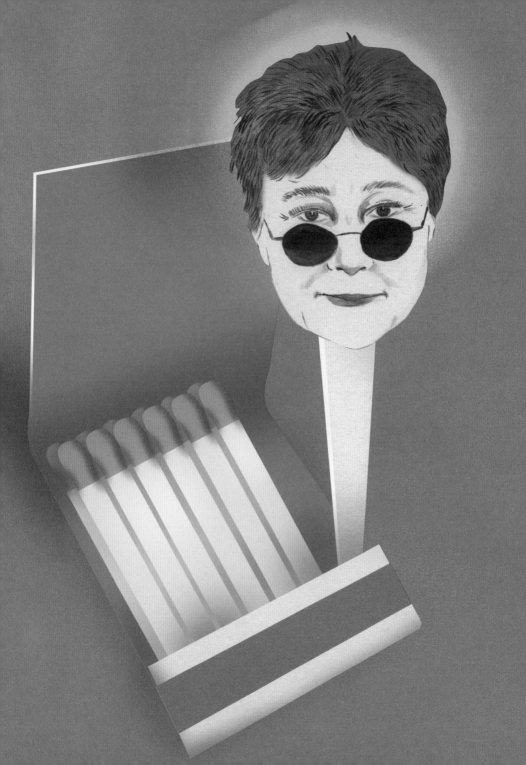

BIBLIOGRAPHY

Agatha Christie:
MacAskill, Hillary. "Agatha Christie's Devon Home Greenway Provides a Glimpse into Her Private Life." *Telegraph* (London). October 8, 2009.

Akira Kurosawa:
Kurosawa, Akira. *Something Like an Autobiography.* New York: Knopf Doubleday Publishing Group, 2011.

Smith, Liam. "Akira Kurosawa." *How Creatives Work* (blog). August 31, 2013. Accessed July 11, 2017. https://howcreativeswork.com/2013/08/31/akira-kurosawa/

Alfred Hitchcock:
Gottlieb, Sidney. *Alfred Hitchcock: Interviews.* Jackson: University Press of Mississippi, 2003.

Allyson Felix:
Mazzo, Lauren. "Rio Olympians Share Their Quirky Pre-Competition Rituals." *Shape Magazine.* August 2016.

Anna Wintour:
Chang, Bee-Shyuan. "A Sneakers-Only Runway." *New York Times.* August 8, 2012.

Lee, Kevan. "The Morning Routines of the Most Successful People." *Fast Company Magazine.* July 2014.

Anthony Bourdain:
Bourdain, Anthony. *Kitchen Confidential and Medium Raw.* London: A&C Black, 2011.

Challa, Janaki. "My Favorite Songs: Anthony Bourdain." *Rolling Stone.* April 11, 2014.

Audrey Hepburn:
Quin, Eleanor. "Paris When It Sizzles (1964)." *Turner Classic Movies* (blog). Accessed July 11, 2017. http://www.tcm.com/tcmdb/title/86269/Paris-When-It-Sizzles/articles.html

Augustus Caesar:
Beck, Aaron, Gary Emery, and Ruth Greenberg. *Anxiety Disorders and Phobias: A Cognitive Perspective.* New York: Basic Books, 2005.

Botham, Noel. *The Book of Useless Information.* New York: Penguin Books, 2006.

Fordham University. "Ancient History Sourcebook: Suetonius (c.69–after 122 CE): The Divine Augustus." Accessed July 11, 2017. https://sourcebooks.fordham.edu/ancient/suetonius-augustus.asp.

Barack Obama:
Cooper, Helen. "A Bit of Quiet Optimism, and Some Superstition, Before a Tight Victory." *New York Times.* November 6, 2012.

Benjamin Franklin:
Diller, Theodore, and Benjamin Franklin. *Franklin's Contribution to Medicine: Being a Collection of Letters Written by Benjamin Franklin Bearing on the Science and Art of Medicine and Exhibiting His Social and Professional Intercourse with Various Physicians of Europe and America.* Brooklyn: A.T. Huntington Books, 1912.

Worrall, Simon. "Ben Franklin Slept Here." *Smithsonian Magazine.* March 2006.

Beyoncé:
Alexander, Ella. "Beyoncé Reveals Her Pre-Show Rituals." *British Vogue.* May 2013.

Björn Borg:
Podnieks, Andrew. *Hockey Superstitions: From Playoff Beards to Crossed Sticks and Lucky Socks.* Toronto: McClelland and Stewart, 2010.

Charles Dickens:
Horne, Jim. "Insomnia—Victorian style." *The Psychologist* (British Psychologist Society), vol. 21 (October 2008): Pages 910, 911.

Coco Chanel:
Baxter, John. *The Golden Moments of Paris: A Guide to the Paris of the 1920s.* New York: Museyon Inc., 2014.

Garcia, Patricia. "A New Look into Coco Chanel's Private Apartment." *Vogue.* September 12, 2014.

Dan Brown:
McKay, Sinclair. "Inspiration Is a Rush of Blood to the Head." *Telegraph* (London). April 27, 2006.

Diane von Furstenberg:
"DVF, Through Glass." YouTube video, 3:48. Accessed July 11, 2017. https://www.youtube.com/watch?v=XhpQ1pD-EsA

Gonzalez, Guadalupe. "The Really Odd Superstitions of 9 Successful Entrepreneurs." *Inc.* (blog). July 14, 2016. Accessed July 11, 2017. http://www.inc.com/guadalupe-gonzalez/ss/famous-entrepreneurs-superstitions.html

Dr. Seuss (Theodor Seuss Geisel):
Katz, Lauren. "Dr. Seuss's Private Hat Collection Is Quite a Sight." *The Two-Way* (blog). February 19, 2014. Accessed July 11, 2017. http://www.npr.org/sections/thetwo-way/2014/02/12/275978426/dr-seusss-private-hat-collection-is-quite-a-sight

Lenkei, Alex. "Dr. Seuss: An American Arts Icon." *Art Works Blog* (blog). March 6, 2015. Accessed July 11, 2017. https://www.arts.gov/art-works/2015/dr-seuss-american-arts-icon

Ella Fitzgerald:
Nicholson, Stuart. *Ella Fitzgerald: A Biography of the First Lady of Jazz.* Abingdon, London: Routledge, 2014.

Ellen DeGeneres:
DeGeneres, Ellen. "Mintologue." *The Ellen Show.* December 9, 2013.

Flannery O'Connor:
O'Connor, Flannery. "Living with a Peacock." *Holiday Magazine.* September 1961.

O'Connor, Flannery. "The King of the Birds." *Mystery and Manners: Occasional Prose.* New York: FSG Classics, 1969.

Franklin D. Roosevelt:
Perry, Warren. "Fears of the Fearless FDR: A President's Superstitions for Friday the 13th." *Smithsonian National Portrait Gallery* (blog). August 13, 2010. Accessed July 11, 2017. http://npg.si.edu/blog/fears-fearless-fdr-president%E2%80%99s-superstitions-friday-13th

Frida Kahlo:
Davies, Lucy. "How Frida Kahlo's Bright, Beautiful Garden Inspired Her." *Telegraph* (London). April 26, 2015.

Lotz, CJ. "A Tribute to Frida Kahlo, Gardener." *Garden and Gun.* January 2017.

Gabriel García Márquez:
Corwin, Miles. "The Journalistic Education of Gabriel García Márquez." *Columbia Journalism Review.* January/February 2010.

Rama, Anahi. "Nobel Winner García Márquez., Master of Magical Realism, Dies at 87." *Reuters.* April 18, 2014.

Stone, Peter H. "Gabriel García Márquez, The Art of Fiction No. 69." *Paris Review.* Issue 82, Winter 1981.

Georgia O'Keeffe:
Telegraph Travel. "The New Mexico Landscapes That Inspired Georgia O'Keeffe." *Telegraph* (London). July 4, 2016.

Runco, Mark A. *Encyclopedia of Creativity,* edited by Mark Runco and Steven R. Pritzker, 2 vols. Cambridge: Academic Press, 1999.

Gertrude Stein:
Clarke, Deborah. *Driving Women: Fiction and Automobile Culture in Twentieth-Century America.* Baltimore: JHU Press, 2007.

Toklas, Alice B., *The Alice B. Toklas Cookbook.* New York: Harper Perennial, 2010.

Gustav Mahler:
Ashley, Tim. "How Mahler Overcame His Wife's Infidelities and His Own Fear of Death to Create the Magnificent 10th Symphony." *Guardian* (London). December 2, 2004.

Painter, Karen. *Mahler and His World.* Princeton: Princeton University Press, 2002.

Gustave Eiffel:
Agüero, Juan Morales. "Illustrious Strangers." *Juventud Rebelde* (Havana). July 2, 2012.

Haruki Murakami:
Murakami, Haruki. "The Running Novelist: Learning how to go the distance." *The New Yorker,* June 9 & 16, 2008.

Wray, John. "Haruki Murakami, The Art of Fiction No. 182." *Paris Review.* Issue 170, Summer 2004.

Heidi Klum:
Snierson, Dan. "Heidi Klum Reveals Victoria's Secret." *Entertainment Weekly.* November 21, 2003.

I. M. Pei:
Pei, I. M., interview by John Tulsa. BBC Radio 3. Accessed July 11, 2017. http://www.bbc.co.uk/radio3/architecture/pa_impei.shtml.

Isabel Allende:
Stein, Sadie. "I Always Start on 8 January." *Paris Review* (blog). January 8, 2013. Accessed July 11, 2017. https://www.theparisreview.org/blog/2013/01/08/"i-always-start-on-8-january"/

James Joyce:
"Feb. 2: On This Day: Ulysses Published." *The Writer's Almanac* (blog). February 2, 2015. Accessed July 11, 2017. http://writersalmanac.org/note/feb-2-on-this-day-ulysses-published/

"Happy Birthday." *The James Joyce Centre* (blog). November 4, 2012. Accessed July 11, 2017. http://jamesjoyce.ie/happy-birthday/

King, Steve. "Bloomsday to Doomsday." *Barnes and Noble Review* (blog). February 2, 2010. Accessed July 11, 2017. http://www.barnesandnoble.com/review/bloomsday-to-doomsday-2

J. K. Rowling:
Rowling, J. K., @jk_Rowling (Twitter). January 7, 2015. Accessed July 11, 2017. https://twitter.com/jk_rowling/status/552814101899247616

Sims, Andrew. "J.K. Rowling Shares Her One Writing Superstition." *Hypable* (blog). January 7, 2015. Accessed July 11, 2017. http://www.hypable.com/j-k-rowling-writing-superstition/

Joan Didion:
Kuehl, Linda. "Joan Didion, The Art of Fiction No. 71." *Paris Review*. Issue 74, Fall–Winter 1978.

John Steinbeck:
Benchley, Nathaniel. "John Steinbeck, The Art of Fiction No. 45." *Paris Review*. Issue 48, Fall 1969.

Schiffman, Jonathan. "The Write Stuff: How the Humble Pencil Conquered the World." *Popular Mechanics*. August 16, 2016. Accessed July 11, 2017. http://www.popularmechanics.com/technology/a21567/history-of-the-pencil/

John Wayne:
Chilton, Martin. "John Wayne: 10 Surprise Facts About the True Grit Star." *Telegraph* (London). June 12, 2015.

Wayne, Alissa. *John Wayne: My Father*. Lanham: Taylor Trade Publications, 1998.

Laboratory of the University of Georgia:
Stokes, Trevor. "Experimenting with Superstition, Scientists Not Above Good-Luck Charms." *San Diego Tribune*. April 5, 2006.

Laird Hamilton:
Casey, Susan. *The Wave: In Pursuit of the Rogues, Freaks, and Giants of the Ocean*. New York: Anchor, 2011.

Hamilton, Laird. *Force of Nature: Mind, Body, Soul, And, Of Course, Surfing*. New York: Rodale, 2010.

Leonard Cohen:
Bray, Elisa. "Leonard Cohen: Before the Gig, a Chant in Latin." *Independent* (London). September 4, 2012.

Lucille Ball:
Brady, Kathleen. *Lucille: The Life of Lucille Ball*. New York: Open Road Media, 2016.

Langley, Liz. "This Friday the 13th, Bone Up on Animal Superstitions." *National Geographic Voices* (blog). September 13, 2013. Accessed July 11, 2017. http://voices.nationalgeographic.com/2013/09/13/animal-superstitions-culture-friday-the-13th/

Ludwig van Beethoven:
Schindler, Anton. *Beethoven As I Knew Him*. North Chelmsford: Courier Corporation, 1966.

Lupita Nyong'o:
Lupita Nyong'o, @lupitanyongo (Instagram), February 21, 2016. Accessed July 11, 2017. https://www.instagram.com/p/BCDsZwdHuTr/?taken-by=lupitanyongo

Marie Curie:
Des Jardin, Julie. "Madame Curie's Passion." *Smithsonian Magazine*. October 2011.

Redniss, Lauren. *Radioactive: Marie and Pierre Curie: A Tale of Love and Fallout*. New York: HarperCollins, It Books, 2010.

Mary Shelley:
Krow, Lenya. "Weird Writing Habits of Authors." *Willow Springs Magazine*. May 30, 2012.

Shelley, Mary. *Rambles in Germany and Italy in 1840, 1842, and 1843*. Vol. 1. London: E. Moxon, 1844.

Maya Angelou:
Plimpton, George. "Maya Angelou, The Art of Fiction No. 119." *Paris Review*. Issue 116, Fall 1990.

Michael Jordan:
Murphy, Ryan. "10 Most Superstitious Athletes." *Men's Fitness* (blog). Accessed July 11, 2017. http://www.mensfitness.com/life/sports/10-most-superstitious-athletes.

Rafferty, Scott. "Flashback: Michael Jordan Begins Legendary Rise With Game-Winning NCAA Championship Shot." *Rolling Stone*. March 29, 2017.

Misty Copeland:
Miller, Randy. "How Misty Copeland Shows Just as Much Grace Onstage and Off." *Self* (blog). October 21, 2014. Accessed July 11, 2017. http://www.self.com/story/misty-copeland-shows-just-much-grace-offstage

Mitoizumi:
"Sumo Wrestler Mitoizumi on Throwing Large Amounts of Salt." My Superstition. *The Guardian*. September 3, 2000.

"Former sekiwake Mitoizumi retires." *The Japan Times*. September 16, 2000. Accessed July 11, 2017. http://www.japantimes.co.jp/sports/2000/09/16/sumo/former-sekiwake-mitoizumi-retires/#.WVFt9FFIBaQ

Napoléon Bonaparte:
Latta, Sara. *Scared Stiff: Everything You Need to Know About 50 Famous Phobias*. New York: Houghton Mifflin Harcourt, 2014.

NASA:
Nasa.gov, Jet Propulsion Laboratory, Cassini. "Lucky Peanuts." April 22, 2016. Accessed July 11, 2017. https://saturn.jpl.nasa.gov/news/22/lucky-peanuts/

Niels Bohr:
Lapham, Lewis. "Miscellany." *Lapham's Quarterly*. Accessed July 11, 2017. http://www.laphamsquarterly.org/magic-shows/miscellany/niels-bohrs-lucky-horseshoe

Hutson, Matthew. "The Science of Superstition." *The Atlantic*. March 2015.

Pablo Picasso:
Huffington, Arianna. *Picasso: Creator and Destroyer*. New York: Simon & Schuster, 1988.

Richardson, John. *A Life of Picasso: The Triumphant Years, 1917–1932*. New York: Alfred A. Knopf, 2010.

Patricia Highsmith:
Wilson, Andrew. *Beautiful Shadow: A Life of Patricia Highsmith*. London: Bloomsbury Publishing, 2008.

Pyotr Ilyich Tchaikovsky:
Tchaikovsky, Lich. *The Life and Letters of Pyotor Tchaikovsky*. London: J. Lane, 1906.

Robert Plant:
Alleyne, Richard. "Led Zeppelin's Pre-Gig Ritual: Coffee and Ironing." *Telegraph* (London). December 10, 2007.

Salvador Dalí:
Dalí, Salvador, interview by Mike Wallace. Harry Ransom Center. Austin, Texas. April 19, 1958. Accessed July 11, 2017. http://www.hrc.utexas.edu/multimedia/video/2008/wallace/dali_salvador_t.html

Serena Williams:
Camber, Rebecca. "Superstitions That Serve Me Well, by Serena Williams." *Daily Mail* (London). July 3, 2007.

Miller, Stuart. "If It Works, Tennis Players Stick with It, Whatever It Is." *New York Times*. August 13, 2013.

Sigmund Freud:
Misemer, Sarah M. *Moving Forward, Looking Back: Trains, Literature, and the Arts in the River Plate*. Lewisburg: Bucknell University Press, 2010.

Taylor Swift:
CNN Entertainment. *"13 Superstitious Celebs."* Updated November 12, 2015. Accessed July 11, 2017. http://www.cnn.com/2015/11/12/entertainment/gallery/superstitious-celebs/index.html

Thom Yorke:
Yorke, Thom, interview by Alec Baldwin. *Here's the Thing* (podcast). April 1, 2013. Accessed July 11, 2017. http://www.wnyc.org/story/278417-thom-yorke/

Tiger Woods:
Ballengee, Ryan. "Why Tiger Woods Wears Red on Sundays, in His Own Words." *The Golf News* (blog). June 26, 2013. Accessed July 11, 2017. https://thegolfnewsnet.com/ryan_ballengee/2013/06/26/why-does-tiger-woods-wear-red-on-sundays-3407/

Gates, Henry Louis. *African American Lives*. Oxford: Oxford University Press, 2004.

Virginia Woolf:
Pendle, George. "To Sit, to Stand, to Write." *Cabinet*. Issue 32 Fire, Winter 2008/09.

Wade Boggs:
Murphy, Ryan. "10 Most Superstitious Athletes." *Men's Fitness* (blog). Accessed July 11, 2017. http://www.mensfitness.com/life/sports/10-most-superstitious-athletes.

Young, John Edward. "Chicken Is a Big Hit with Baseball's Wade Boggs." *Christian Science Monitor*. January 2, 1985.

Winston Churchill:
O'Mara, Lesley. "A Purr-fect Read . . ." *Daily Express* (London). November 30, 2012.

Yoko Ono:
Yoshimoto, Midori. *Into Performance: Japanese Women Artists in New York*. New Brunswick: Rutgers University Press, 2005.

ACKNOWLEDGMENTS

I owe an enormous debt of gratitude to my husband, David Flaherty, for his assistance on the production of this book and his support through the countless hours I spent in the studio creating it. I would like to thank my editor, Caitlin Kirkpatrick, for her invaluable feedback and attention to detail, Kristen Hewitt for her elegant design, and the wonderful team at Chronicle: Claire Fletcher, Janine Sato, Steve Kim, Megan Gendell, Jane Tunks Demel, Bridget Watson Payne, and Christina Amini. Thank you to Len Small for the assignment that opened the door that inspired me to step into this project. Thank you to my mom and friends Susan Cozzi, Julia Rothman, Josh Gosfield, and Camille Sweeney for their encouragement along the way. Thank you to the public figures that shared their private practices and the writers, editors, publishers, and interviewers who made the research possible.